TINY
TATTOOS

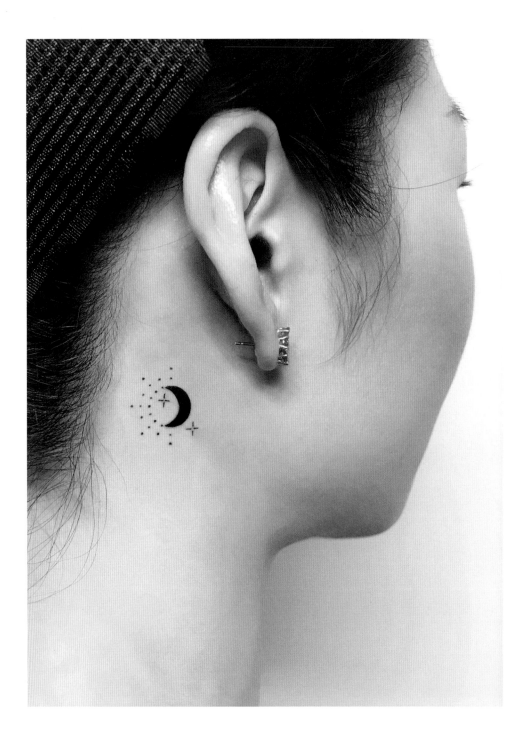

TINY
TATTOOS

1,000 SMALL
INSPIRATIONAL ARTWORKS

REBECCA VINCENT

HARPER
DESIGN

An Imprint of HarperCollins Publishers

First published in 2020
in the United Kingdom
by Quarto Publishing plc,
an imprint of The Quarto Group.

Tiny Tattoos
Copyright © 2020
Quarto Publishing plc,
an imprint of The Quarto Group.

First published in 2020 by
Harper Design
An Imprint of HarperCollins*Publishers*
195 Broadway
New York, NY 10007
Tel: (212) 207-7000
Fax: (855) 746-6023
harperdesign@harpercollins.com
www.hc.com

Distributed throughout North America by
HarperCollins*Publishers*
195 Broadway
New York, NY 10007

ISBN 978-0-06-298533-0

Library of Congress Control Number
has been applied for.

Printed in China

First Printing, 2020

Conceived, edited, and designed by
Quarto Publishing plc
an imprint of The Quarto Group
6 Blundell Street
London N7 9BH

QUAR.325448

Senior editor: Kate Burkett
Edited by: Ruth Patrick
Illustrator: Kuo Kang Chen
Picture research: Luped media research
Deputy art director: Martina Calvio
Art director: Gemma Wilson
Publisher: Samantha Warrington

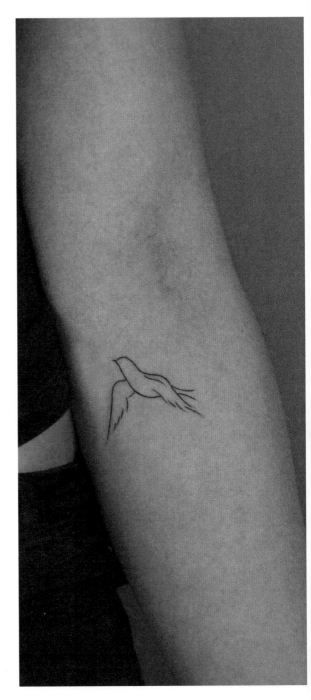

CONTENTS

About this book

This reference library of more than 1,000 mini works of art, in a range of styles and a myriad of carefully organized subjects, is a source of inspiration for tattoo artists or for anyone browsing for a foray into ink.

Introduction (see pages 8–17)

Tattoo artist and Instagram star Rebecca Vincent introduces us to the world of tiny tattoos, describes her experiences of working as a tattooist, and discusses what to consider when getting a tattoo. A placement guide reveals the parts of the body with the highest pain thresholds and which spots are best to prevent the artwork from dropping out, fading, or blurring.

The Tattoo Directory (see pages 18–187)

The directory is organized into 11 easy-to-understand categories, such as Animals, Nature, Travel, Symbols, and Food, and includes tips and advice from Rebecca about the symbology and origin of the designs.

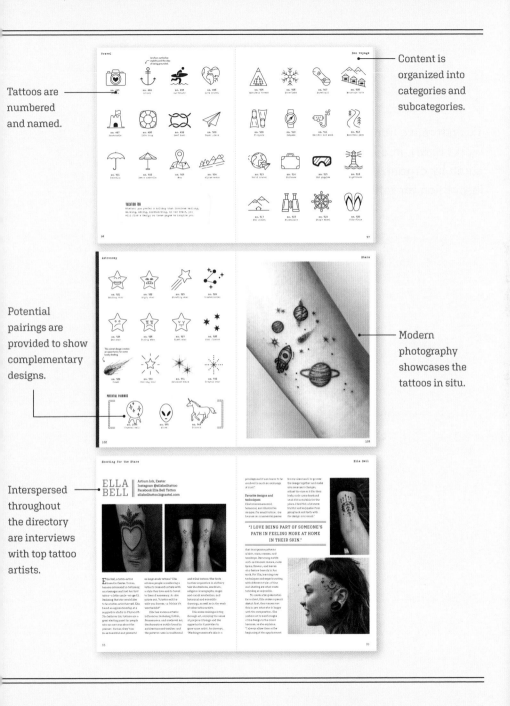

Tattoos are numbered and named.

Content is organized into categories and subcategories.

Potential pairings are provided to show complementary designs.

Modern photography showcases the tattoos in situ.

Interspersed throughout the directory are interviews with top tattoo artists.

Introduction

I started tattooing around seven years ago in Leeds. I had always been a huge fan of tattoos and started getting my own when I was twenty. The whole process fascinated me. Never in my wildest dreams did I believe that this would be my job. After the birth of my daughter, I started drawing again. I hadn't done so since college, and any spare time I had would be spent sketching. This led me to a studio called Nostalgia, which is where I began my career.

Ever since I was a little girl, I would take my inspiration from nature and I transferred this into my tattooing style. I would say that my tattoos are illustrative and delicate, which attracts a lot of first-timers.

One of the best bits of my job is meeting a wide range of people. A tattoo can be a very cathartic experience for the customer, and I have had some of the most interesting conversations. It's never boring I can tell you!

REBECCA VINCENT

Tattoo artist at
Parliament Tattoo, London
Instagram @rebecca_vincent_tattoo

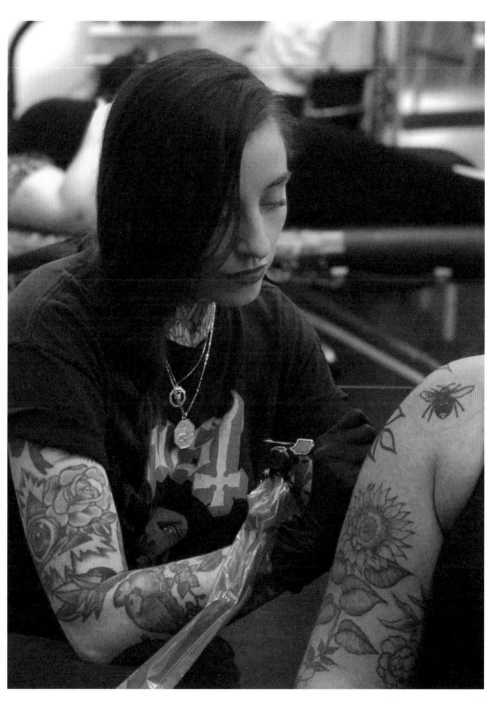

Thinking about getting a tiny tattoo?

THERE ARE MANY REASONS WHY SMALLER TATTOOS ARE POPULAR. EVEN A PERSON WHO IS COVERED IN LARGER PIECES OF ARTWORK WILL HAVE A SMALL TATTOO, OR SIX, ON THEIR BODY.

The idea of getting tattooed can be an incredibly daunting experience for some. It is a complete unknown and, let's be honest, they hurt! More often than not, if someone is considering starting this tattoo journey, they opt toward something small. I cannot tell you how many times I've tattooed something tiny on someone for their first and they've come back to me for more. It is true what they say, it is very addictive.

In my experience, small tattoos can have very personal meanings. I have tattooed loved ones' handwriting and initials.

One very memorable time a customer wanted dots on her body to represent where her mother had received chemotherapy. It is a great honor to do these, because it can help the customer through a difficult time.

Sometimes people want what they want, just because. I have had customers turning a certain age and wanting to mark this occasion by getting a tattoo. The design is usually very personal to them and can be absolutely anything, from something that represents their hobbies to their favorite food.

Another reason people like a smaller tattoo is that

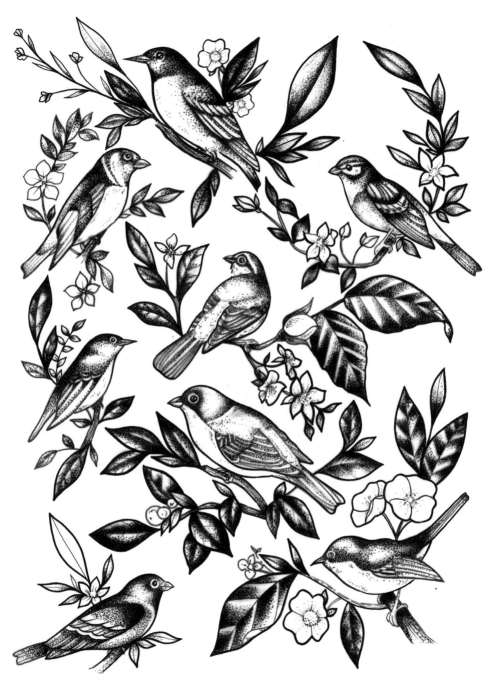

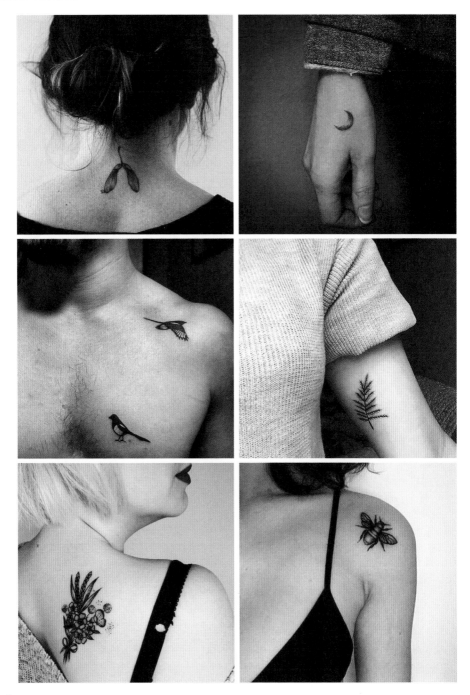

it can be hidden easily. I have tattooed doctors and teachers who have preferred that their design be small and discreet so it cannot be seen at work. This is also something that you should seriously consider. As great as tattoos are, they should not affect your job, so be wise when thinking about placement.

They also make great gap fillers. When you start to get more heavily tattooed it creates annoying spaces, which can be very frustrating. Small tattoos are perfect for those areas.

Tattoos are more popular now than they ever have been. Because of this, the quality of art just gets better and better. There are styles now that I definitely didn't see 15 years ago.

The smaller the tattoo, the less scope there is for it to be intricate. For healing purposes, it cannot be complicated. Lines grow slightly larger over time and this can mean blurring. It is very important to consider this when picking your design. What can look amazing and detailed now may not necessarily have the greatest longevity and eventually blur.

Tattoos look slightly different when they are healed. They won't be as crisp as the day you got them but I actually prefer it when they've settled in and have become part of your body.

Saying this, please be aware of doctored images when doing your research. Social media is a great way to find inspiration but there are images out there that aren't real. I know that I have been shown photos of tattoos in the past that were actually photoshopped, so not actually possible. When I book a customer in, I like them to show me things they've seen and that have piqued their interest. It is my job to advise them on what is possible and what is not. Sometimes this can be disappointing for them as the idea they had sadly won't work. But know that this is because I want you to get the best tattoo you can. I always advise to go a little larger, simply because the tattoo will last longer and you can get more detail in there. Your tattoo artist will explain all of this to you.

I really cannot stress enough how important it is that you do your research. Tattoos are permanent and believe me, removal is way more painful! Make sure that you have picked an artist that is right for you. Social media is a great way to find the perfect one. You'll be able to see their portfolio of work, which will tell you if their style is right for you or not. See if you can search for healed tattoos, as this will give you a better idea of what you will get. Trust your chosen artist. If they say something isn't going to work, I guarantee they are right. We are here to guide and help you, so don't be afraid to ask questions.

Where should your tattoo go?

IN MY EXPERIENCE, I HAVE FOUND THAT SOME OF THE MOST POPULAR AREAS FOR TATTOOS TEND NOT TO BE THE BEST WHEN IT COMES TO THE LONGEVITY FOR THE PIECE.

Many times I am asked to tattoo ankles, fingers, sides of feet, and hands. The skin in these areas doesn't lend kindly to tattoos. Many people experience the ink dropping out or blurring. This is something to seriously consider, especially if it is a small tattoo.

TATTOO PAIN

Now it should be said that pain is relative to the individual. What could really hurt me might not be as bad for you and vice versa. There are areas on the body that pain seems to be universally agreed on but this may not be the case for you. On the next page I have rated the different areas of the body and their likely pain levels based on my experience as a tattooer.

SUN EXPOSURE

Tattoos—and your whole body—should always be protected from the sun. Make sure that they are covered with a high SPF sunscreen to help prevent premature fading. When on vacation especially, try to keep them covered as much as possible if you want them to keep their original boldness.

TRENDINESS

As with fashion, tattoos have trends too. We all remember the Chinese characters from the '90s. Make sure a tattoo is something you see yourself having in the years to come. It can be easy to get caught up in the tattoo buzz and then later regret your decision.

DURABILITY

There are areas of the body on which tattoos don't last as well as others. Hands, feet, and ankles are prime examples. The tattoos can drop out or even blur and this will affect the quality of the piece, especially if it is a small tattoo.

AGING

Everybody's skin ages eventually and this means that the quality of your tattoo will too. This is something to consider if you don't want a design that isn't as crisp as when you first get it. There are some areas on the body that are better than others for this, such as arms and legs.

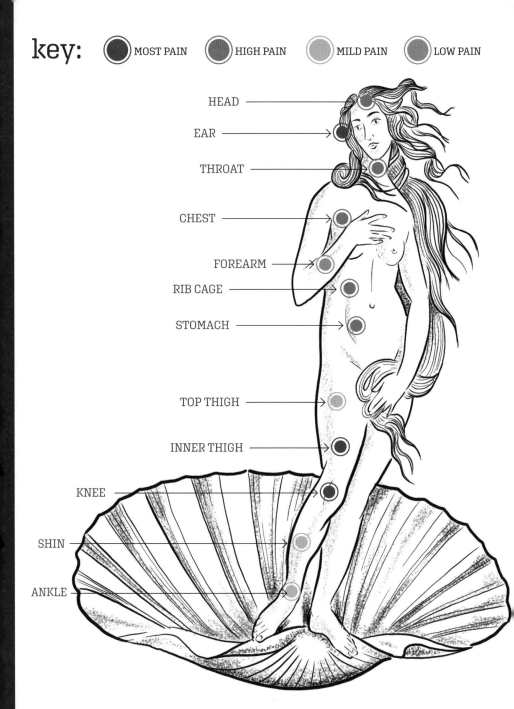

key:

MOST PAIN HIGH PAIN MILD PAIN LOW PAIN

HEAD

EAR

THROAT

CHEST

FOREARM

RIB CAGE

STOMACH

TOP THIGH

INNER THIGH

KNEE

SHIN

ANKLE

FRONT OF THE BODY

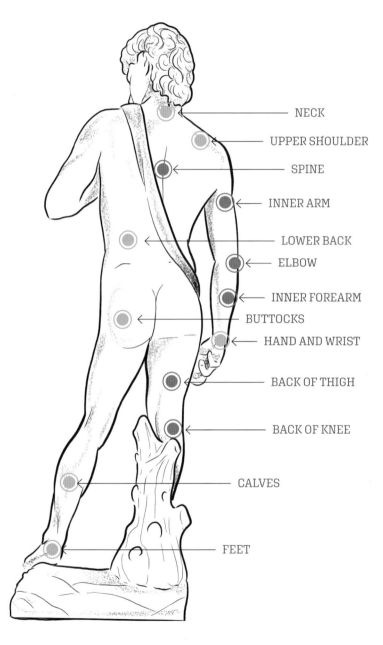

NECK

UPPER SHOULDER

SPINE

INNER ARM

LOWER BACK

ELBOW

INNER FOREARM

BUTTOCKS

HAND AND WRIST

BACK OF THIGH

BACK OF KNEE

CALVES

FEET

BACK OF THE BODY

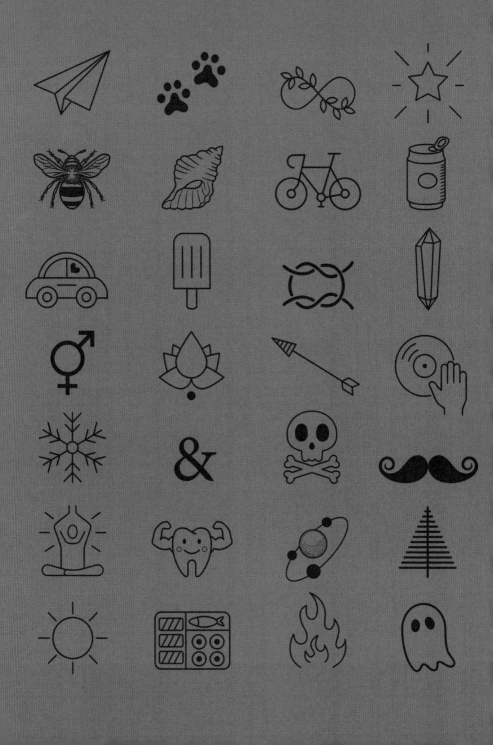

TATTOO DIRECTORY

NATURE

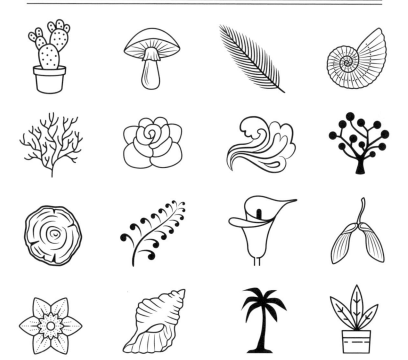

no. 1
Peacock feather

no. 2
Tail feather

no. 3
Wing feather

no. 4
Striped feather

no. 5
Downy feather

no. 6
Flight feather

no. 7
Fiery feather

no. 8
Magic feather

A feather tattoo may give the wearer spiritual protection.

no. 9
Leafy feather

no. 10
Hatched feather

no. 11
Bristle feather

REALISTIC FEATHERS

Realistic feather tattoos are very popular with both men and women. They may represent freedom, travel, courage, and the idea of following your dreams.

no. 12
Semiplume feather

no. 13
Flourish feather

no. 14
Frondy feather

STYLIZED FEATHERS

The patterns in these stylized feather designs look very striking when inked on the body. They can symbolize the spirit world or the loss of a loved one.

no. 15
Feather silhouette

no. 16
Tribal feather

no. 17
Geometric feather

no. 18
Simple feather

no. 19
Shadowed feather

no. 20
Native American feather

no. 21
Pointed feather

no. 22
Freedom feather

no. 23
Arrow feather

no. 24
Celtic feather

no. 25
Dagger feather

no. 26
Diamond feather

no. 27
Spiral feather

no. 28
Spiritual feather

no. 29
Magic mushrooms

no. 30
Cone mushrooms

no. 31
Puffballs

no. 32
Fly agaric

Mushrooms symbolize power, magic, and the circle of life.

no. 33
Chanterelle mushroom

no. 34
Portobello mushroom

no. 35
Oyster mushroom

no. 36
Toadstool

no. 37
Fairy toadstool

no. 38
Cartoon toadstool

no. 39
Simple fungi

no. 40
Button mushroom

POTENTIAL PAIRINGS

no. 342
Fairy

no. 301
Delicate insect

no. 256
Leaping rabbit

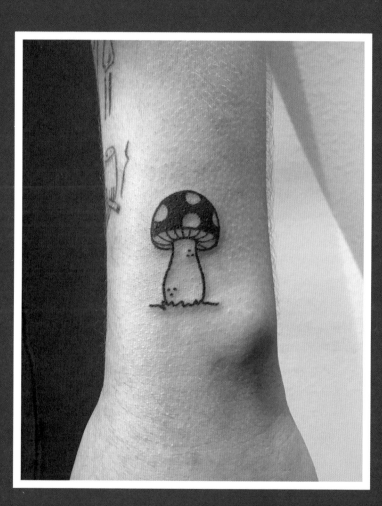

no. 41
Wild rose

no. 42
Little leaves

no. 43
Crown imperial

no. 44
Lily

no. 45
Berries

no. 46
Snowball

no. 47
Japanese anemone

no. 48
Neroli

no. 49
Simple lily

no. 50
Cosmos

no. 51
Tulip

FLOWER SYMBOLISM

Flowers typically symbolize positive qualities and feelings such as love, natural beauty, and passion. They work well as a stand-alone tattoo or part of a floral group.

The rose is the traditional symbol of love.

no. 52
Rosebud

no. 53
Lily-flowered tulip

no. 54
Dragon rose

SYMMETRY

Many of the designs shown on these pages are symmetrical, which makes for an arresting tattoo and emphasizes the beautiful patterns that can be found in flowers.

no. 55
Aerial rose

no. 56
Gerbera

no. 57
Daffodil

no. 58
Daisy

no. 59
Periwinkle

no. 60
Frangipani

no. 61
Dahlia

no. 62
Sunflower

no. 63
Chrysanthemum

no. 64
Spiky tulip

no. 65
3-D rose

no. 66
Open lily

no. 67
Scarlet pimpernel

no. 68
Calla lily

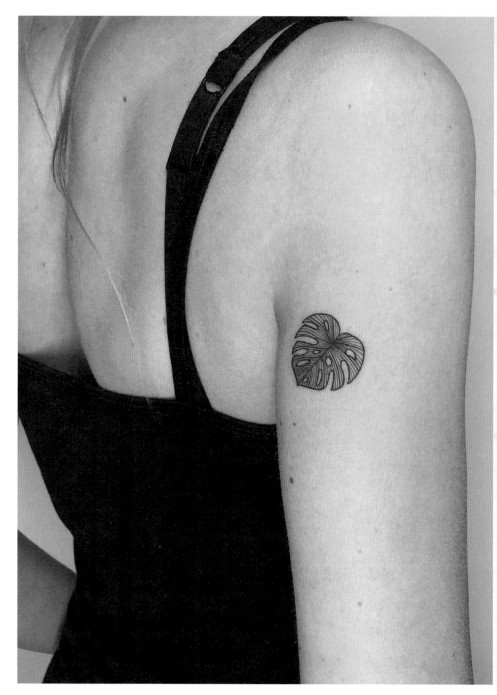

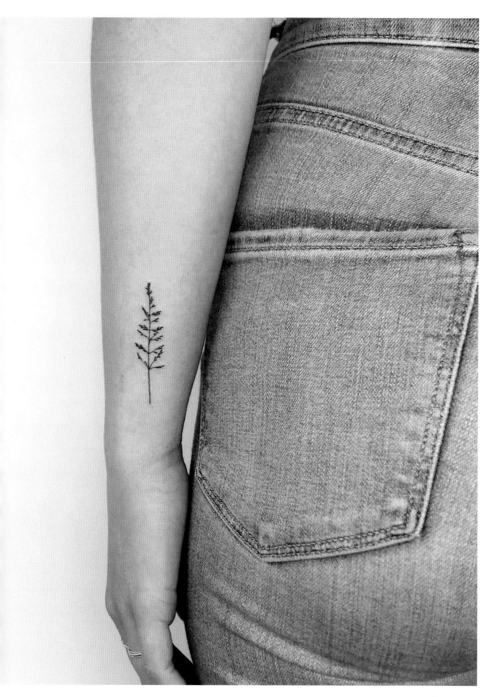

no. 69
Maple leaf

no. 70
Infinity leaves

no. 71
Tendril leaf

no. 72
Cheese plant
silhouette

no. 73
Classic leaf

no. 74
Holly

no. 75
Samara seeds

no. 76
Shamrock

no. 77
Leafy branch

no. 78
Symmetrical branch

no. 79
Branch silhouette

SERENE LEAVES

Leaves evoke feelings of peace, calm, and serenity, and also represent new life and happiness. Spring or fall colors can be used in a tattoo to convey additional meaning.

no. 80
Leaves with berries

no. 81
Delicate leaves

no. 82
Retro leaves

LEAF DETAIL

Leaves can look elegant tattooed with fine lines and realistic detail or filled in for a more graphic interpretation.

no. 83
Cannabis leaf

no. 84
Flowering branch

no. 85
Lotus leaves

no. 86
Budding branch

no. 87
Palm frond

no. 88
Maple silhouette

no. 89
Bud outline

no. 90
Frond silhouette

no. 91
Leaves with detail

no. 92
Single stem

The cheese plant is a very popular design. It represents long life.

no. 93
Simple leaf

no. 94
Cheese plant

no. 95
Love leaf

no. 96
Fern fronds

no. 97
Palm tree

no. 98
Swirly tree

no. 99
Stripy tree

no. 100
Triangle tree

no. 101
Cone tree

no. 102
Deciduous tree

no. 103
Christmas tree

no. 104
Rocket tree

no. 105
Simple pine

no. 106
Idea tree

no. 107
Lollipop tree

no. 108
Small pine

no. 109
Fall tree

no. 110
Larch

SACRED TREES

Trees traditionally represent strength, resilience, and the beauty of the natural world. Many tree varieties are held sacred in some cultures and religions.

TREE SHAPES

The distinctive branching shape of trees can create a unique and meaningful tattoo. The simple outlines shown on these pages are particularly effective.

no. 111
Branching tree

no. 112
Fir tree

no. 113
Windy tree

no. 114
Log cross section

no. 115
Christmas tree
silhouette

no. 116
Small beech

no. 117
Dotty tree

no. 118
Spruce tree

no. 119
White pine

no. 120
Geometric pine

no. 121
Stripy spruce

no. 122
Bobble tree

no. 123
Small spruce

no. 124
Weeping tree

no. 125
Money tree

no. 126
Prickly pear

no. 127
Saguaro

no. 128
Saguaro silhouette

The cactus represents warmth, endurance, and protection.

no. 129
Potted tulip

no. 130
Potted daisy

no. 131
Hedgehog cactus

no. 132
Devil's ivy

no. 133
Simple stems

no. 134
Bobble plant

no. 135
Cordyline

no. 136
Cute flowerpot

POTENTIAL PAIRINGS

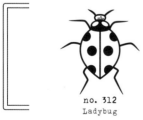

no. 312
Ladybug

no. 550
Beating sun

no. 73
Classic leaf

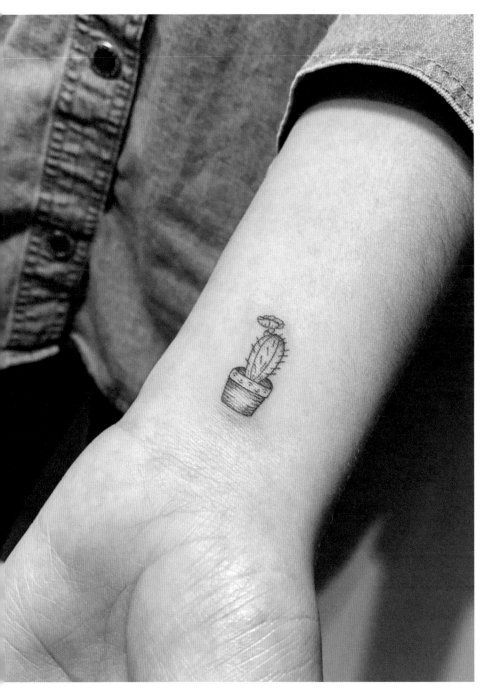

The archetypal conch is perhaps the most popular shell tattoo.

no. 137
Conch

no. 138
Banded wedge shell

no. 139
Venus clam

no. 140
Aerial whelk

no. 141
Murex

no. 142
Lightning whelk

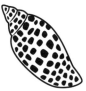

no. 143
Junonia

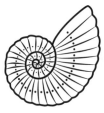

no. 144
Ammonite

no. 145
Olive shell

no. 146
Turret shell

no. 147
Tulip banded shell

SHELL TATTOOS

You may get a shell tattoo to remind you of a particularly memorable holiday or just the peace and tranquility of being on the beach.

no. 148
Scallop

no. 149
Topshell

no. 150
Whelk

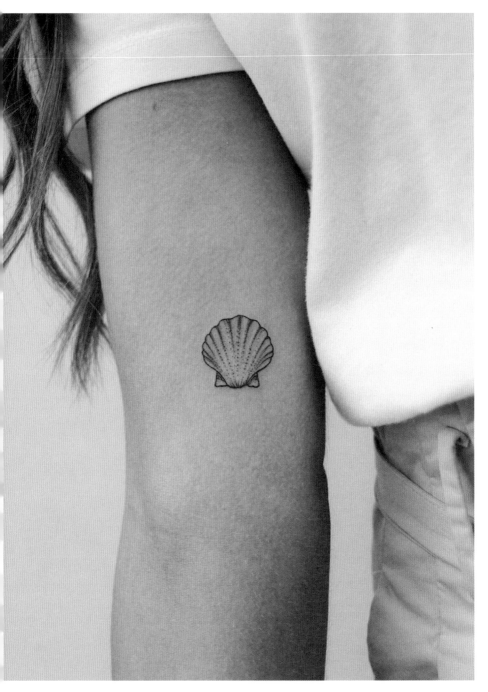

no. 151
Branching coral

no. 152
Black coral

no. 153
Furbelows

no. 154
Furbelow detail

If you love botanicals
and the sea, seaweed
is the perfect tattoo.

no. 155
Branching seaweed

no. 156
Bladder wrack

no. 157
Sea kelp

no. 158
Seaweed silhouette

no. 159
Elkhorn coral

no. 160
Staghorn coral

no. 161
Delicate coral

SEAWEED AND CORAL

The pleasing
patterns and
structures
of seaweed
and coral
make for
interesting
and unusual
tattoos.
They evoke
the harmony
and beauty
of marine
environments.

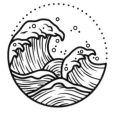

no. 162
Splashing wave

no. 163
Message in a bottle

no. 164
Hokusai's wave

MOODS OF THE SEA

Few people can tire of looking at the sea and waves breaking on a beach. The tattoos on this page aim to represent some of the many moods of the waves.

no. 165
Porthole

no. 166
Crashing waves

no. 167
Choppy waves

no. 168
Teardrop waves

no. 169
Hexagon waves

no. 170
Triangle waves

no. 171
Crest of a wave

no. 172
Gentle waves

no. 173
Breaking waves

no. 174
Spiral waves

no. 175
Seabirds

no. 176
Swirling waves

no. 177
Simple wave

no. 178
Whirlpool

ARMELLE

Private studio in Paris, France
Instagram @armelle_stb_tattoo
Facebook Armelle Stb

Armelle is a tattoo artist based in Paris, France, although she also works as a guest artist for other studios, including Parliament Tattoo in London. The first tattoo she ever did was on herself: of a trumpet in a bottle of exploding champagne. She now has quite a few tattoos, including lots of tiny designs as they can be used to fill in spaces. Armelle began tattooing because someone offered to teach her, and she just went with the flow from there. She explains: "I fell in love with it and can't picture myself doing anything else. I was studying architecture and I just stopped that to get into tattooing."

Armelle is unsure whether attitudes to tattoos are changing, pointing out that, of course, people stare a little bit if someone is heavily tattooed. However, she feels it is getting better and better, and that people are now generally more accepting of tattoos. She believes tiny tattoos

are accessible for everyone, especially as they are often a first step toward getting more or bigger tattoos. She suggests people have tiny tattoos anywhere that they have space, but advises against significant others' names!

Design inspiration, motifs, and techniques

Armelle has many sources of inspiration, including vintage items such as Grandma's crockery, wallpaper, and dresses. She also loves William Morris. Her favorite subjects to tattoo are flowers because they lend themselves so well to small designs. Seashells are also a recurring theme in her work. Armelle elaborates, "I love to do small branches, flowers, and seashells, mostly. But I'm easy with everything." She also likes to tattoo unusual designs, such as bobby pins, hot air balloons, masked faces, gloved hands, and palm trees.

Armelle prefers to use artist's pens and basic pencils for drawing her designs on paper first, although she also loves to draw directly on the skin. In terms of working practice, people usually tell her what they would like done,

"TINY TATTOOS ARE 'ACCESSIBLE' FOR EVERYONE AND IT'S OFTEN THE FIRST STEP BEFORE MORE OR BIGGER TATTOOS."

including the tattoo's subject, placement, and size. She then gives them an appointment and comes up with a suitable design. Whether she draws directly on the client's skin or sketches out the design first,

Armelle modifies the design as she works if that is what the customer wants—as she explains, "We decide together."

ANIMALS

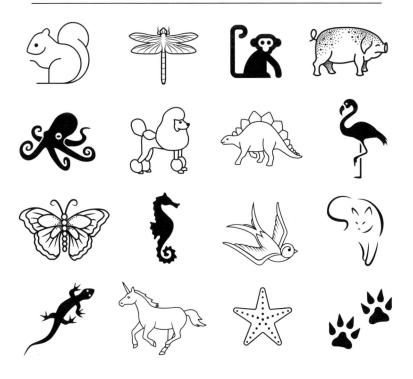

Animals

no. 179
Simple owl

no. 180
Geometric bird

no. 181
Peace eagle

no. 182
Peace dove

no. 183
Finch

no. 184
Bird on a wire

no. 185
Kiwi

no. 186
Returning swallow
silhouette

no. 187
Bird's nest

no. 188
Puffin

no. 189
Flamingo

BIRD SYMBOLISM

According
to legend, a
seaman with
a swallow
tattoo
had sailed
5,000 miles.
The bird
tattoos on
these pages
represent
freedom,
physicality,
and the idea
of return.

no. 190
Swallow outline

no. 191
Rooster

no. 192
Swallow

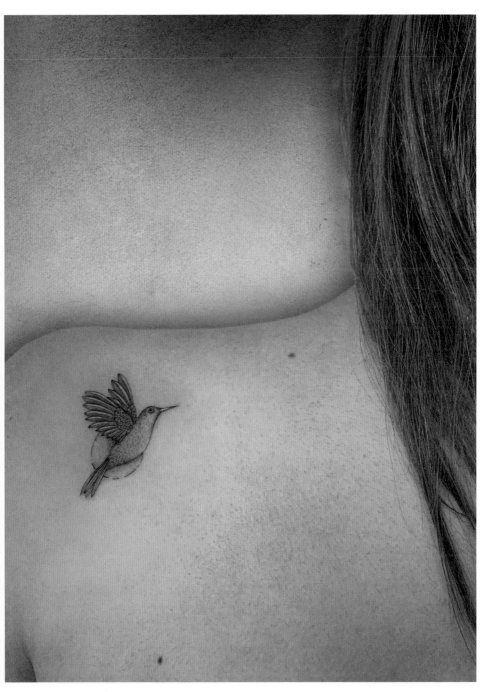

FLOCK OF BIRDS

Tiny tattoos of birds look very effective arranged as a flock either on the ankle or the wrist. Use birds on the wing to convey a positive message.

no. 193
Detailed owl

no. 194
Bath-time duck

no. 195
Robin

no. 196
Roosting bird

no. 197
Calling bird

no. 198
Swallow silhouette

no. 199
Songbird on branch

no. 200
Songbird with flower

no. 201
Cherry blossom songbird

no. 202
Songbird on lookout

no. 203
Penguin

no. 204
Parrot

no. 205
Toucan

no. 206
Woodpecker

no. 207
Elephant

no. 208
Zebra

no. 209
Leopard

no. 210
Stag

no. 211
Wolf

no. 212
Giraffe

no. 213
Squirrel

no. 214
Water buffalo

no. 215
Monkey

no. 216
Lion

no. 217
Moose

BORN TO BE WILD

You may consider getting a tattoo of your favorite wild animal. Whether you admire its way of life or share some of its traits, a tiny wild animal tattoo is sure to draw admirers.

The rhinoceros evokes endurance and agility.

no. 218
Koala

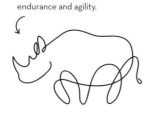

no. 219
Rhinoceros

no. 220
Bear

Animals

The simple outline of a cat is a very effective tattoo.

no. 221
Sleepy cat

no. 222
Cat at rest

no. 223
Simple cat

no. 224
Cat silhouette

no. 225
Pouncing cat

no. 226
Adoring cat

no. 227
Curly cat

no. 228
Love cat

no. 229
Cat with moon

no. 230
Stretching cat

no. 231
Semicolon cat

no. 232
Peeping cat

POTENTIAL PAIRINGS

no. 402
Fish skeleton

no. 330
Cat prints

no. 727
Cone of yarn

Animals

no. 233
Love dog

no. 234
Dachshund

no. 235
Labrador

no. 236
Collie

no. 237
Poodle

no. 238
Fox terrier

no. 239
Husky profile

no. 240
Labrador profile

no. 241
Doberman

no. 242
Husky

no. 243
Boxer

no. 244
French bulldog

POTENTIAL PAIRINGS

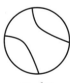

no. 640
Tennis ball

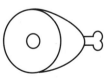

no. 377
Ham

no. 573
Bones

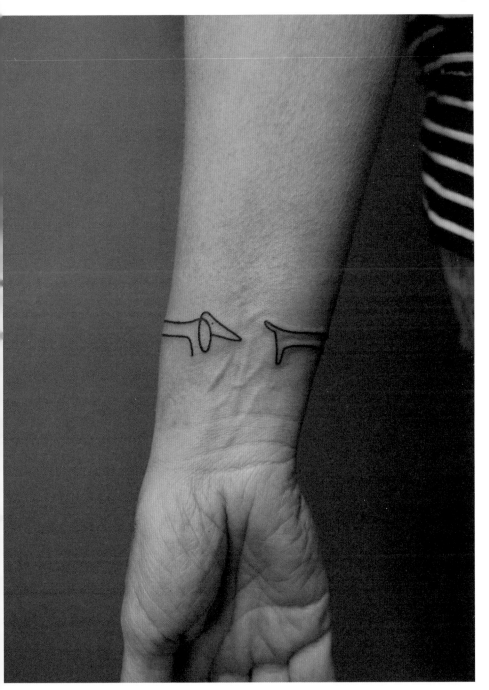

Animals

no. 245
Pig

no. 246
Birdcage

no. 247
Hamster

no. 248
Goldfish

no. 249
Mouse

no. 250
Love bunny

no. 251
Hedgehog

no. 252
Swirly mouse

no. 253
Chipmunk

no. 254
Tortoise silhouette

no. 255
Aerial tortoise

The hare is a mysterious creature often associated with the moon.

no. 256
Leaping hare

POTENTIAL PAIRINGS

no. 969
Heart

no. 96
Fern fronds

Pair this carrot with no. 250 or 256.

no. 363
Carrot

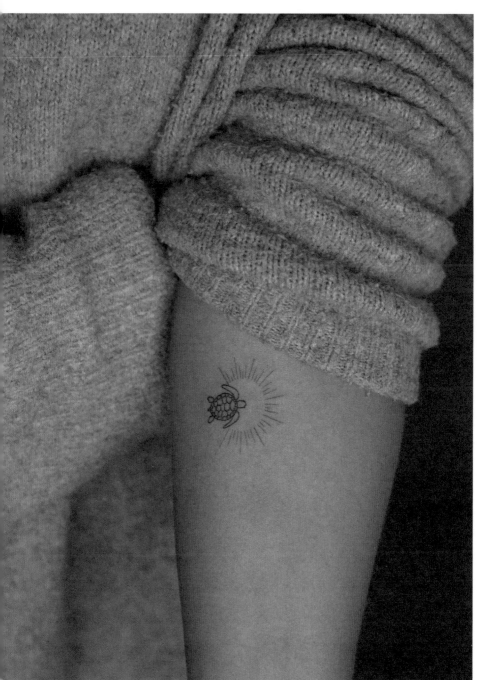

no. 257
Starfish

no. 258
Octopus

no. 259
Crab

no. 260
Whale tail

no. 261
Stingray

no. 262
Seal

no. 263
Seahorse

The whale is a symbol of compassion and creativity.

no. 264
Blue whale

no. 265
Shark fin

no. 266
Shark

no. 267
Dolphin

UNDER THE SEA

Tattoos associated with water may symbolize protection, healing, and purity. Add your favorite marine creature from this selection for a winning tattoo design.

no. 268
Oyster with pearl

no. 269
Jellyfish

no. 270
Fish silhouette

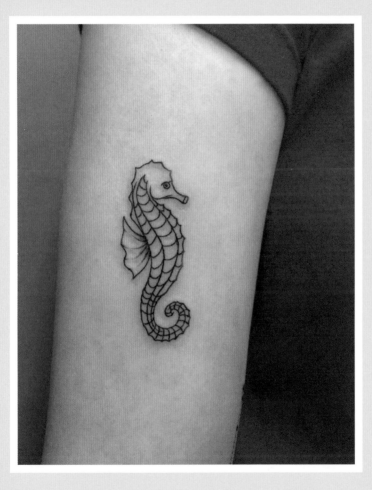

no. 271
Lizard silhouette

no. 272
Snake silhouette

no. 273
Snake

no. 274
Crocodile

no. 275
Cobra

no. 276
Aerial lizard

no. 277
Iguana

no. 278
Frog

Heqet was the Egyptian goddess of fertility, depicted as a frog.

no. 279
Komodo dragon

no. 280
Frog silhouette

no. 281
Lizard outline

REPTILES AND AMPHIBIANS

Reptiles play a key role in the creation stories of many religions. Frogs and amphibians also represent aspects of spirituality in some ancient cultures.

no. 282
Worm

no. 283
Tadpole

no. 284
Gecko

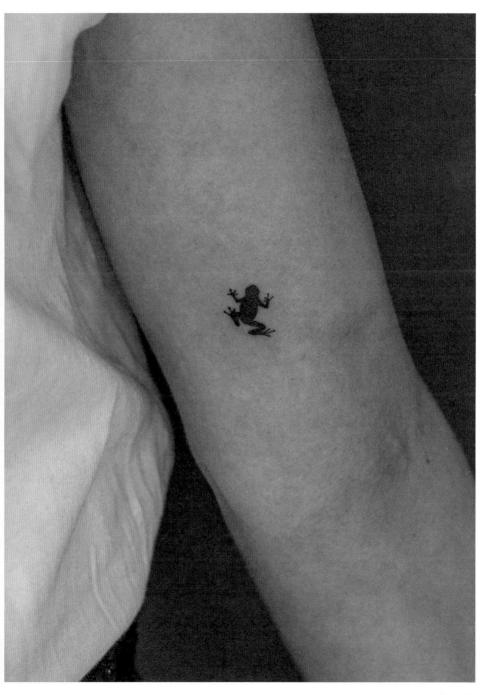

Animals

A playful tattoo of a T. rex: what's not to love?

no. 285
Tyrannosaurus rex

no. 286
Spinosaurus

no. 287
Dimetrodon

no. 288
T. rex

no. 289
Plesiosaur

no. 290
Velociraptor

no. 291
Triceratops

no. 292
Woolly mammoth

no. 293
Mosasaurus

no. 294
Stegosaurus

no. 295
Pterodactyl

no. 296
Brontosaurus

POTENTIAL PAIRINGS

no. 144
Ammonite

no. 542
Meteor

no. 326
Animal prints

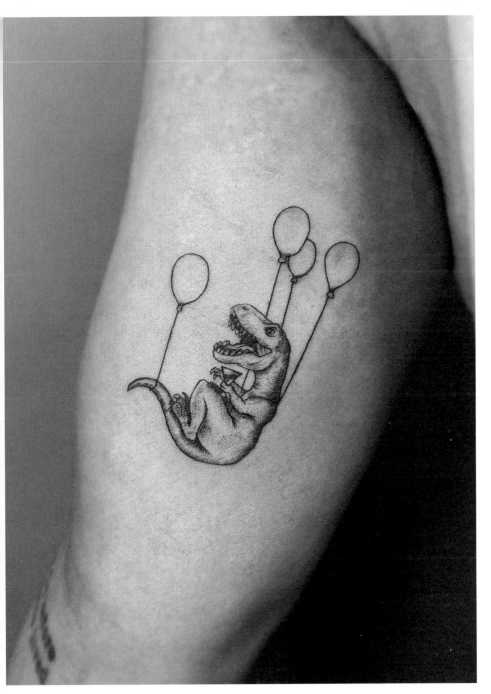

no. 297
Bee

no. 298
Dragonfly

no. 299
Spotty moth

no. 300
Antler moth

no. 301
Delicate insect

no. 302
Speckled moth

no. 303
Spot wing moth

no. 304
Butterfly

no. 305
Insect silhouette

no. 306
Lacewing

no. 307
Patterned moth

Show your love of mini beasts by getting a butterfly tattoo.

no. 308
Black moth

no. 309
Patterned butterfly

no. 310
Spotty butterfly

INSECT TATTOOS

Bees are very popular tattoos, but the whole insect world provides endless inspiration. Moths and butterflies are beautiful creatures that can symbolize rebirth and change.

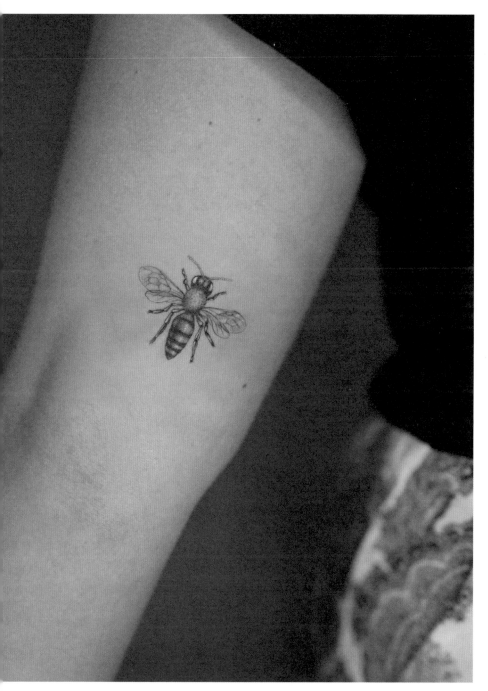

no. 311
Beetle

no. 312
Ladybug

no. 313
Patterned bug

no. 314
Winged bug

no. 315
Ant

no. 316
Antler bug

no. 317
Louse

no. 318
Striped bug

no. 319
Spotty bug

no. 320
Delicate bug

no. 321
Pond skater

no. 322
Aphid

POTENTIAL PAIRINGS

no. 41
Wild rose

no. 126
Prickly pear

no. 71
Tendril leaf

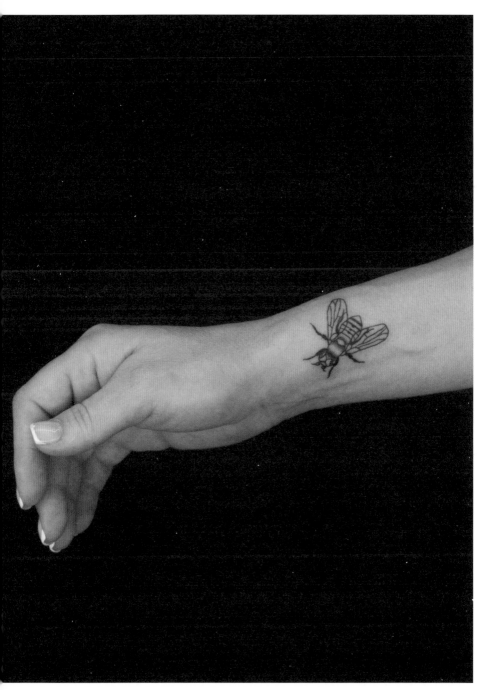

no. 323
Horse hooves

no. 324
Webbed feet silhouette

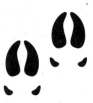

no. 325
Deer prints

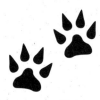

no. 326
Animal prints

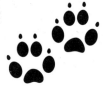

no. 327
Dog prints

no. 328
Webbed feet

no. 329
Songbird prints

no. 330
Cat prints

Bear prints can symbolize courage and motherhood.

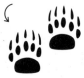

no. 331
Bear front paws

no. 332
Bear hind paws

no. 333
Porcupine prints

no. 334
Simple bear prints

no. 335
Bird prints

no. 336
Amphibian prints

ANIMAL TRACKS

Animal print tattoos generally represent stability, power, and mobility. You may want to honor your favorite pet by getting their paw prints inked on your body.

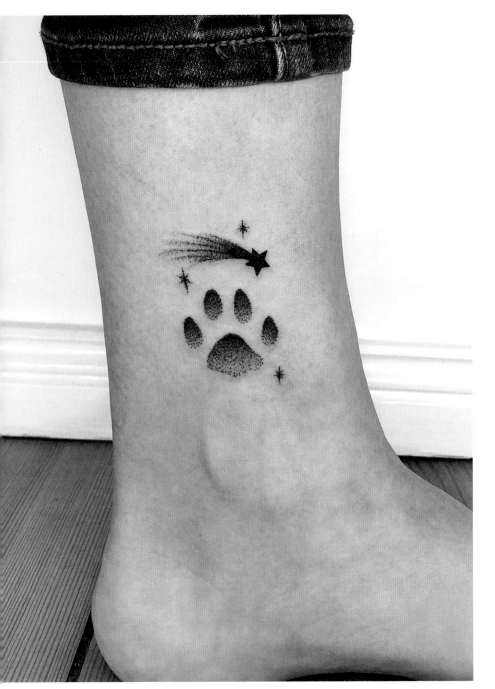

Animals

no. 337
Genie

no. 338
Griffin

no. 339
Three-headed dragon

no. 340
Yeti silhouette

no. 341
Werewolf

no. 342
Fairy

no. 343
Mermaid

A unicorn is a
symbol of divine
power and purity

no. 344
Unicorn

no. 345
Dragon

no. 346
Medusa

no. 347
Dragon silhouette

no. 348
Unicorn silhouette

POTENTIAL PAIRINGS

no. 173
Breaking waves

no. 1087
Prism crystal

no. 523
Shooting star

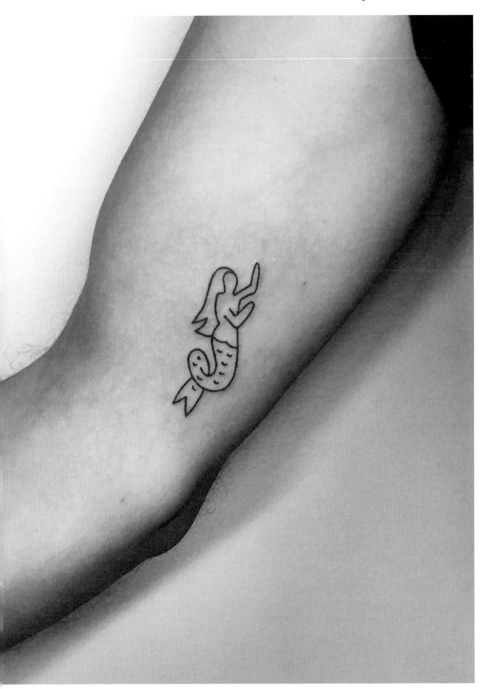

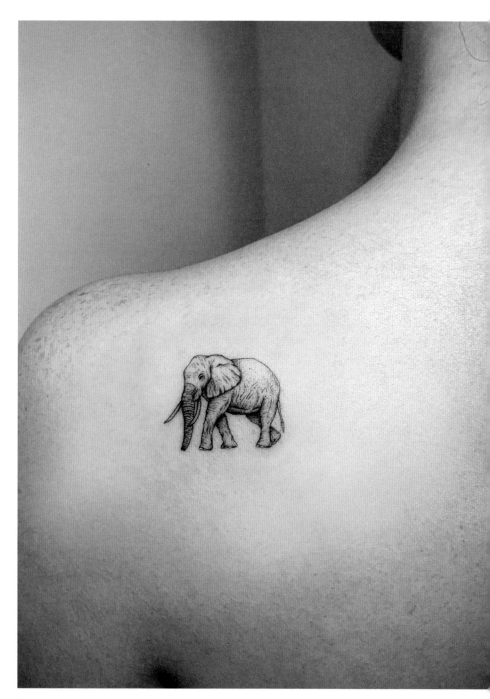

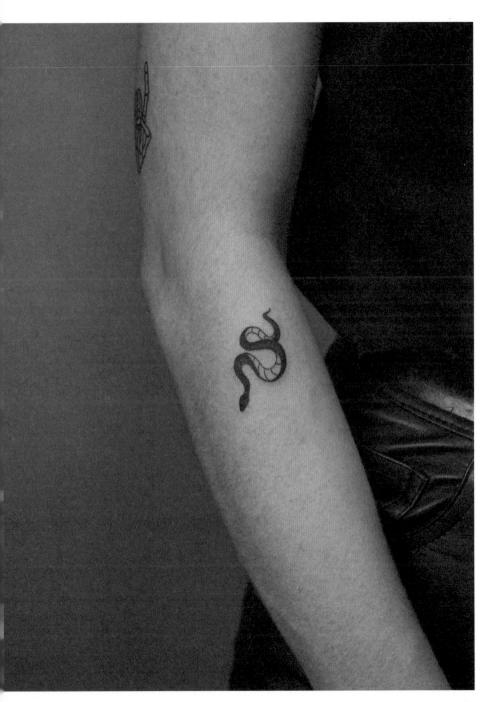

FOOD

Cherries can symbolize fertility.

no. 349
Blackberry

no. 350
Pineapple

no. 351
Apple

no. 352
Cherries

no. 353
Apple core

no. 354
Pear

no. 355
Pomegranate

no. 356
Lemon

no. 357
Strawberry

no. 358
Half lemon

no. 359
Watermelon

TUTTI-FRUTTI

In history, art, and culture, fruits are loaded with symbolism; for example, an apple represents knowledge or temptation. Do your research to find the one that works for you.

no. 360
Grapes

no. 361
Banana

no. 362
Blueberries

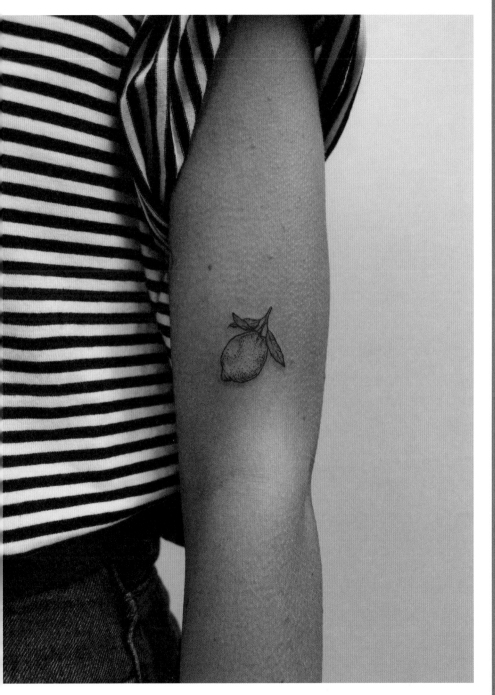

Food

no. 363
Carrot

no. 364
Tomato

no. 365
Garlic

no. 366
Turnip

no. 367
Leek

no. 368
Cauliflower

If you're a fan of
spicy food, why not
get a chile?

no. 369
Chile

no. 370
Eggplant

no. 371
Half capsicum

no. 372
Broccoli

no. 373
Spring greens

HEALTHY VEGETABLES

Vegetables
have all
manner
of health
benefits,
from
improving
eyesight
to boosting
energy.
Show your
appreciation
by getting
a tattoo of
your favorite
vegetable.

no. 374
Peas

no. 375
Capsicum

no. 376
Avocado

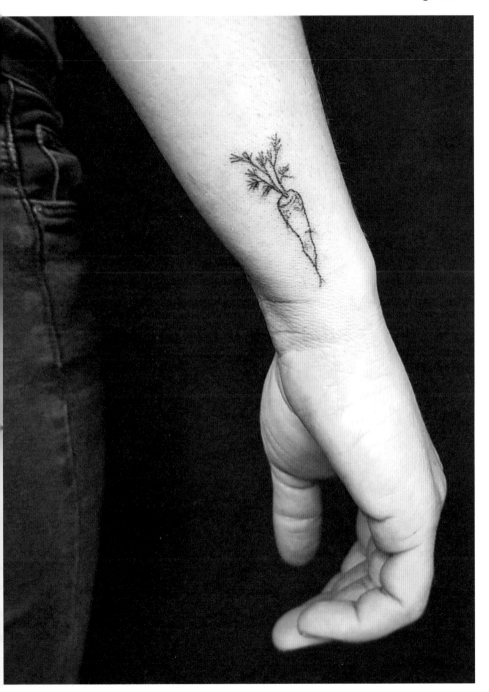

no. 377
Ham

no. 378
Sausage

no. 379
Chicken drumstick

no. 380
Bread

no. 381
Pizza

no. 382
Slice of pizza

no. 383
Toasted sandwich

no. 384
Cheese

Show off your
pumpkin pie tattoo
on Thanksgiving.

no. 385
Pumpkin pie

no. 386
Steak

no. 387
Corncob

no. 388
Boiled egg

POTENTIAL PAIRINGS

no. 778
Chef's hat

no. 456
Beer

no. 635
Soccer

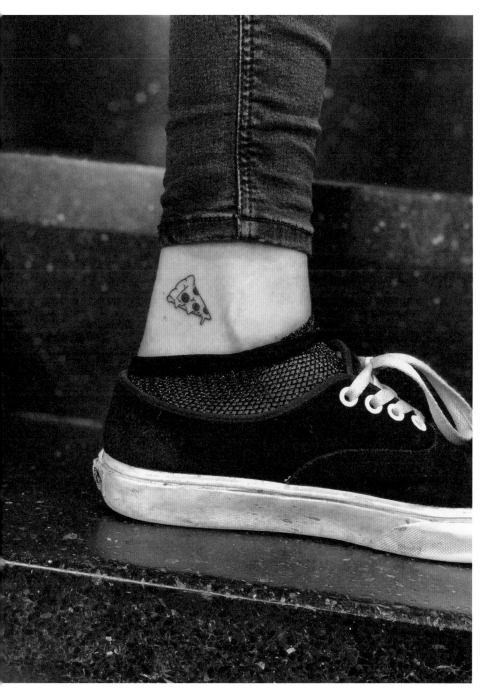

Food

no. 389
Chinese takeout

no. 390
Ketchup and
mustard

no. 391
Chicken wrap

no. 392
Kebab

no. 393
Taco

If you love burgers,
why not get this
cute design?

no. 394
Burger

no. 395
Fried egg

no. 396
Roast chicken

no. 397
Penne

no. 398
Farfalle

no. 399
Rigatoni

no. 400
Conchiglie

POTENTIAL PAIRINGS

no. 779
Bubbling pot

no. 772
Cleaver

no. 595
Stomach

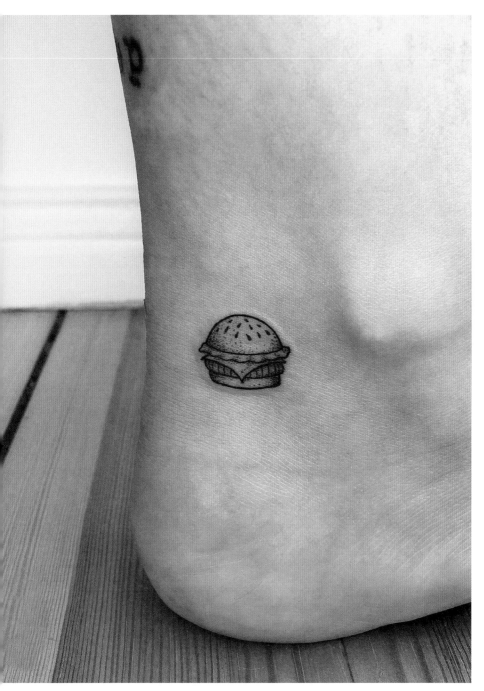

no. 401
Onigiri

no. 402
Fish skeleton

no. 403
Tuna nigiri

no. 404
Salmon nigiri

no. 405
Temaki

no. 406
Crab nigiri

no. 407
Uramaki

Temaki is a cone-shaped sushi roll, with vegetables and/or fish.

no. 408
Simple temaki

no. 409
Maki cube

no. 410
Simple uramaki

no. 411
Maki

SUSHI BANQUET

Sushi lovers have many types to choose from, and you could have a whole banquet tattooed on your body. From salmon to sushi rolls and soups to sides, all the designs are here.

no. 412
Soy sauce

no. 413
Tuna

no. 414
Chopsticks

SUSHI TRADITION

Sushi has a long history, stretching back more than 2,000 years. It is a key element in Japanese cuisine and culture, and it can be very visually appealing, making it a great tattoo subject.

no. 415
Trout

no. 416
Miso soup

no. 417
Lobster miso soup

no. 418
Sushi rolls

no. 419
Takeout noodles

no. 420
Sushi box

no. 421
Fish roe

no. 422
Clams

no. 423
Lobster

no. 424
Mackerel

no. 425
Kushiyaki

no. 426
Shrimp

no. 427
Simple shrimp nigiri

no. 428
Shrimp nigiri

no. 429
Afternoon tea

no. 430
Morning tea

no. 431
Croissant

no. 432
Latte

no. 433
Milk

no. 434
Coffee to go

no. 435
Cappuccino

no. 436
Coffee cup

If you love your job as a barista, you could get this coffee bean tattoo.

no. 437
Coffee beans

no. 438
Espresso maker

no. 439
Kettle

no. 440
Teapot

POTENTIAL PAIRINGS

no. 513
World travel

no. 781
Oven mitt

no. 444
Cake with icing

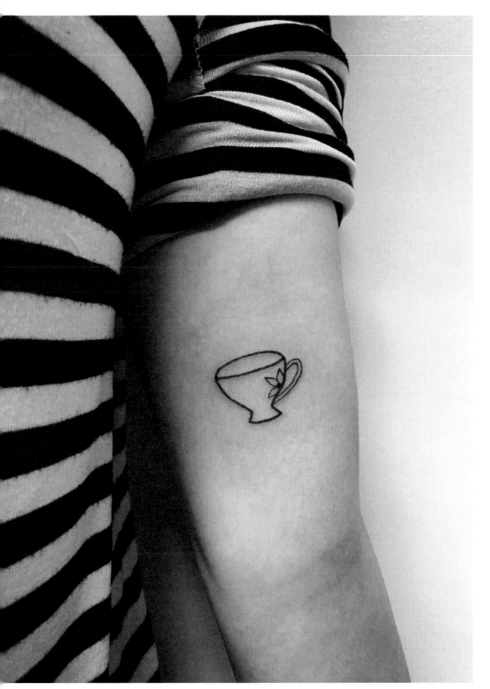

no. 441
Cupcake

no. 442
Gelato

no. 443
Popcorn

no. 444
Cake with icing

A mini ice cream tattoo would look super cute.

no. 445
Ice cream

no. 446
Gummy bear

no. 447
Ice pop

no. 448
Lollipop

no. 449
Cheesecake

no. 450
Cookies

no. 451
Iced donut

SWEET TOOTH

Sometimes you may want a tattoo just for the fun of it; one that does not necessarily hold a symbolic meaning. These cute and light-hearted dessert tattoos would fit the bill perfectly.

no. 452
Swiss roll

no. 453
Chocolate cake

no. 454
Donuts

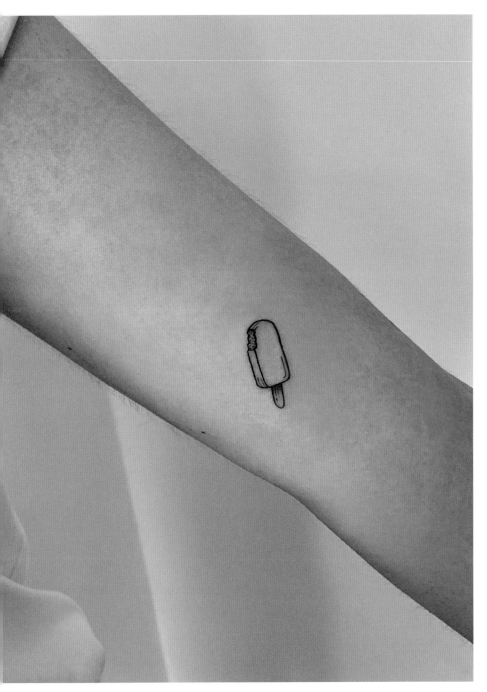

no. 455
Liquor

no. 456
Beer

no. 457
Shot glass

no. 458
Cocktail shaker

no. 459
Can of soda

no. 460
Wine

no. 461
Cheers!

Love tequila? Get
a shot with lime
tattooed!

no. 462
Tequila

no. 463
Cocktail

no. 464
Whiskey

no. 465
Martini

no. 466
Champagne

POTENTIAL PAIRINGS

no. 358
Half lemon

no. 747
Eighth notes

no. 382
Slice of pizza

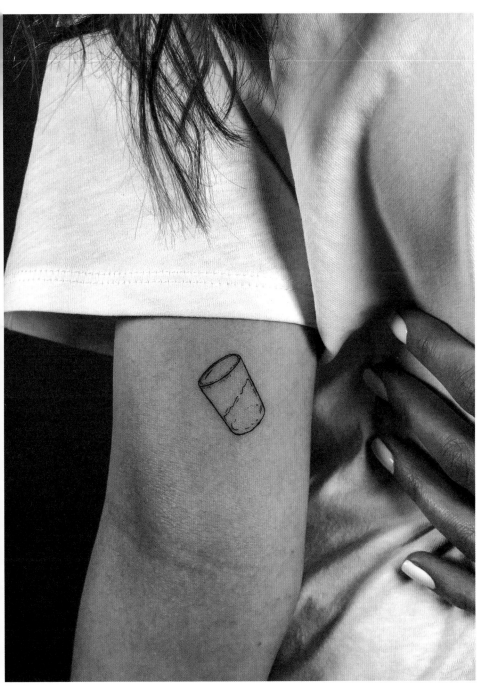

ELLA BELL

Artium Ink, Exeter
Instagram @ellabelltattoo
Facebook Ella Bell Tattoo
ellabelltattoo.bigcartel.com

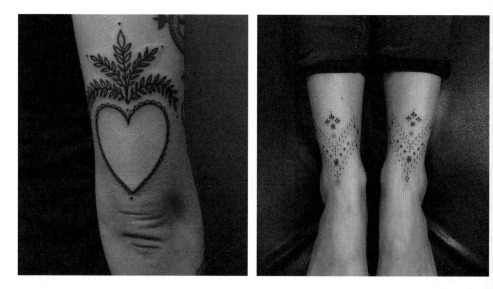

Ella Bell, a tattoo artist based in Exeter, Devon, became interested in tattooing as a teenager and had her first tattoo—a little circle—at age 15. Realizing that she would like to be a tattoo artist herself, Ella found an apprenticeship at a supportive studio in Plymouth. She believes tiny tattoos are a great starting point for people who are nervous about the process—for her, they "can be as beautiful and powerful as large-scale tattoos." Ella advises people considering a tattoo to research artists with a style they love and to travel to them if necessary. As she points out, "A tattoo will be with you forever, so I think it's worthwhile!"

Ella has various artistic influences, including Gothic, Renaissance, and medieval art; the decorative motifs found in architecture and textiles; and the patterns seen in traditional and tribal tattoos. She finds further inspiration in old fairy-tale illustrations, woodcuts, religious iconography, magic and occult symbolism, and botanical and scientific drawings, as well as in the work of other tattoo artists.

Ella loves making a living through art, enjoying the sense of purpose it brings and the opportunity it provides to grow as an artist. As she says, "Marking someone's skin is a

privilege and it's an honor to be involved in such an exchange of trust."

Favorite designs and techniques

Ella loves ornamental, botanical, and illustrative designs. For small tattoos, she focuses on ornamental pieces for my client and me to go over the design together and make any necessary changes, adjust the size so it fits their body, or do some freehand work if it is suitable for the piece. I find this a lot more fruitful and enjoyable than going back and forth with the design over email."

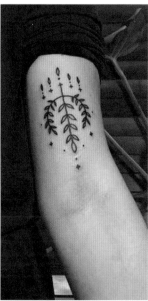

> ## "I LOVE BEING PART OF SOMEONE'S PATH IN FEELING MORE AT HOME IN THEIR SKIN."

that incorporate patterns of dots, stars, crosses, and teardrops. Recurring motifs such as crescent moons, nude forms, flowers, and leaves also feature heavily in her work. For Ella, learning new techniques and experimenting with different styles of line and shading are what make tattooing so enjoyable.

To create a bespoke tattoo for a client, Ella makes a pencil sketch first, then traces over this in pen when she is happy with the composition. She prefers not to send images of the design to the client because, she explains, "I always allow time at the beginning of the appointment

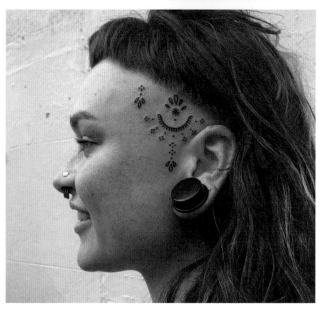

TRAVEL

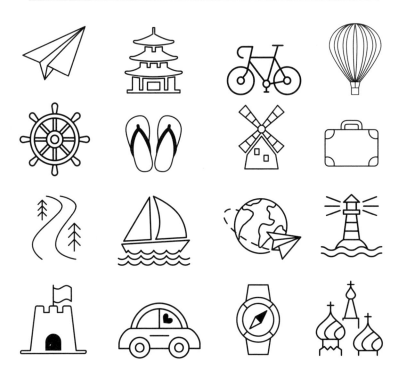

no. 467
Windmill

no. 468
Volcano

no. 469
Pagoda

no. 470
Ionic column

A tattoo of the Eiffel Tower is instantly recognizable.

no. 471
Landmark skyline

no. 472
Sydney Opera House

no. 473
Eiffel Tower

no. 474
Saint Basil's Cathedral

no. 475
Pyramids

no. 476
CN Tower

no. 477
Big Ben

WORLD LANDMARKS

Getting a tiny tattoo of an iconic landmark is a fun way to remember a great holiday. You could add more tattoos with each holiday to create a group design.

no. 478
Statue of Liberty

no. 479
Colosseum

no. 480
Christ the Redeemer

no. 481
Camper van

no. 482
Submarine

no. 483
Skateboard

no. 484
Broken skateboard

no. 485
Bicycle

no. 486
Airplane

no. 487
Trolley car

Hot air balloons are popular tattoos as a symbol of freedom.

no. 488
Hot air balloon

no. 489
Penny farthing

no. 490
Car

no. 491
Boat

no. 492
Train

POTENTIAL PAIRINGS

no. 537
Earth

no. 265
Shark fin

no. 545
Spiral sun

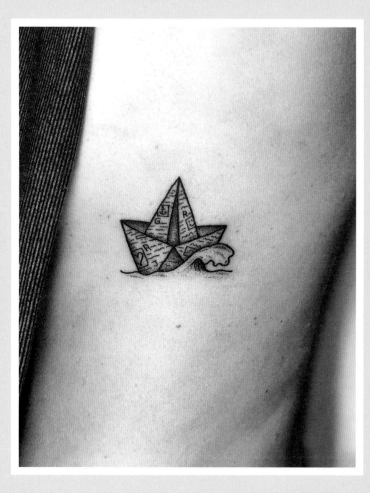

Anchors symbolize
stability and the idea
of being grounded.

no. 493
Camera

no. 494
Anchor

no. 495
Surfboard

no. 496
Love travel

no. 497
Sandcastle

no. 498
Life ring

no. 499
Reef knot

no. 500
Paper plane

no. 501
Umbrella

no. 502
Beach umbrella

no. 503
Map

no. 504
Alpine scene

VACATION FUN

Whether you prefer a vacation that involves sailing,
walking, skiing, snowboarding, or the beach, you
will find a design on these pages to inspire you.

no. 505
Mountain forest

no. 506
Snowflake

no. 507
Snowboard

no. 508
Mountain huts

no. 509
Flippers

no. 510
Compass

no. 511
Snorkel and mask

no. 512
Mountain pass

no. 513
World travel

no. 514
Suitcase

no. 515
Ski goggles

no. 516
Lighthouse

no. 517
Ski chalet

no. 518
Binoculars

no. 519
Ship's wheel

no. 520
Flip-flops

ELLIOT PITTAM

Old Habits Tattoo, London
Instagram @paradisehellbow
Facebook Old Habits Tattoo

Elliot Pittam became a tattoo artist when a friend gave him an old setup. The first tattoo he did was a circus tent on his ankle—he admits he didn't really know how to set up the machine, but the tattoo is still there today. Elliot never studied art at school, but always knew he wanted to do something aesthetically stimulating.

Although there is less of a stigma around tattooing, Elliot does not want this to be lost altogether—"It's what drew me to it in the first place. A rebellion against the norm. A bit of a dirty aesthetic that I liked." For people considering a tattoo, Elliot advises not to overthink things or put too much emphasis on meaning, as ways of thinking change over time. Instead, he suggests getting something visually pleasing and taking advice from the artist on positioning. For him, tiny tattoos are less daunting and more subtle— they can have a powerful

mpact, whether used alone
or to "fill up awkward gaps
between bigger tattoos."
However, he stresses that
they may not "age gracefully
and that once-beautiful tiny
tattoo will look like a gray
smudge in years to come."

"AS A KID, TATTOOS LOOKED TOUGH; AS AN ADULT, I THINK THEY SHOULD STILL LOOK TOUGH AND HAVE THE ABILILTY TO SHOCK."

Artistic influences and favorite designs

Elliot is influenced by Eastern
art and cultures, but with a
London twist—"I like tattooing
to have a balance, like light and
dark. The Eastern beauty with
that London blunt trauma." He
still works with people who
influenced him—Liam Sparkes,
Duncan x, Caleb Kilby, and
Ryan Jessiman. Elliot feels his
designs are always evolving,
although he enjoys using
patterns like stripes and scales.
For him, the black and negative
blunt contrast looks strong, and
so he attempts to fit this effect
into his work. Favorite imagery
includes roses, palm trees,
tigers, spiders, and snakes.

 Elliot emphasizes that Old
Habits is a traditional street
studio that welcomes client
walk-ins. He believes this
approach encourages tattoo
artists to mix things up design-
wise. His own working process
begins with finding reference
material—from magazines,
matchbooks, adverts, fashion—
before putting his own spin
on it. He likes to use larger
tattoos as anchor points and
add smaller tattoos around
them. Although days as a tattoo
artist are similar, he enjoys the
opportunity to do something
new that steers his work in a
new direction or allows him
to use a new reference.

ASTRONOMY

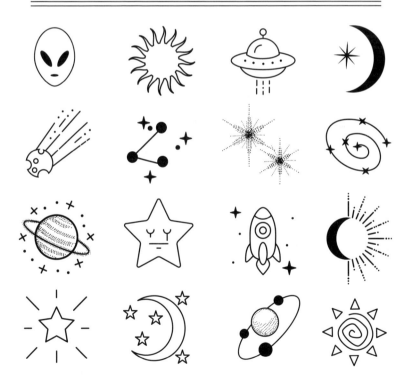

no. 521
Smiling star

no. 522
Angry star

no. 523
Shooting star

no. 524
Constellation

no. 525
Sad star

no. 526
Crying star

no. 527
Upset star

no. 528
Star cluster

This comet design creates an opportunity for some lovely shading.

no. 529
Comet

no. 530
Shining star

no. 531
Detailed stars

no. 532
Graphic star

POTENTIAL PAIRINGS

no. 1033
Crystal ball

no. 535
Alien

no. 344
Unicorn

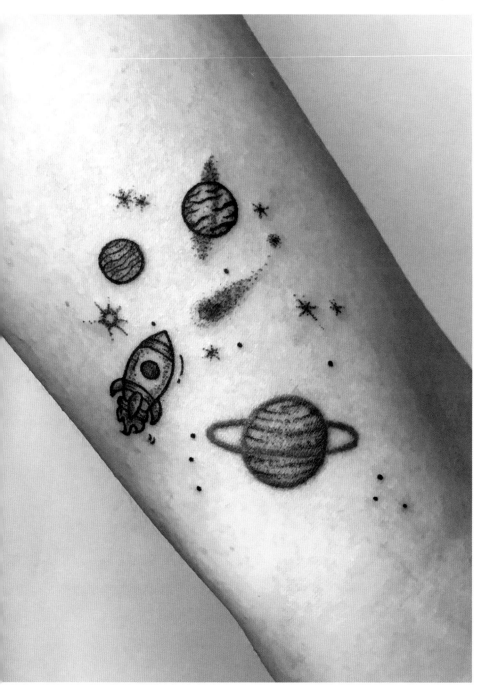

Astronomy

Saturn makes an effective
small tattoo because of
its distinctive rings.

no. 533
Saturn

no. 534
Speed of light

no. 535
Alien

no. 536
Space suit

no. 537
Earth

no. 538
Galaxy

no. 539
Astronaut

no. 540
Spaceship

no. 541
Solar system

no. 542
Meteor

no. 543
Orbit

no. 544
Rocket

POTENTIAL PAIRINGS

no. 916
Mars

no. 561
Moon craters

no. 521
Smiling star

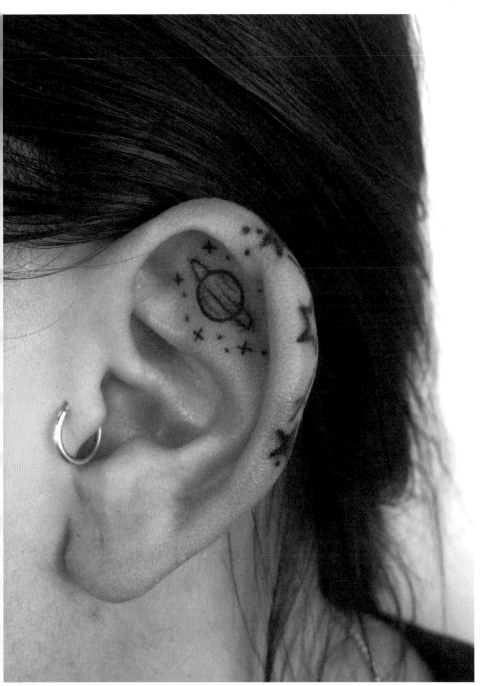

no. 545
Spiral sun

no. 546
Pointed sun

no. 547
Beaming sun

no. 548
Geometric sun

This dark sun design is an interesting take on the traditional sun.

no. 549
Tribal sun

no. 550
Beating sun

no. 551
Aztec sun

no. 552
Sun silhouette

no. 553
Sun and moon

no. 554
Swirly sun

no. 555
Sunset

no. 556
Wavy sun

no. 557
Hippie sun

no. 558
Dotty sun

CENTRAL SUN

The sun represents strength and energy, and can also symbolize rebirth. It is a universal focal point for many cultures, and thus has always been a popular tattoo design.

MYSTICAL MOON

The moon appears in the discourses of many of the world's cultures. The phases of the moon are effective small tattoos and represent femininity, magic, and mysticism.

no. 559
Moon and stars

no. 560
Man in the moon

no. 561
Moon craters

no. 562
Delicate moon

no. 563
Moon silhouette

no. 564
Shining moon

no. 565
New moon

no. 566
Waxing crescent

no. 567
First quarter

no. 568
Waxing gibbous

no. 569
Full moon

no. 570
Waning gibbous

no. 571
Last quarter

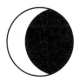

no. 572
Waning crescent

MEG LANGDALE

Private studio in Leicester, England
Instagram @meglangdaletattoo
Facebook Meg Langdale Tattoo

Before becoming a tattoo artist, Meg Langdale was a freelance illustrator while also holding down a full-time job. Meg's first tattoo was a tiny black heart on her wrist, although she now has a combination of larger and smaller designs. The first tattoo she did was a small rose on herself. As Meg got more and more tattoos, spent lots of time in tattoo studios, and had her work displayed at tattoo conventions, she found she was often being asked to produce tattoo designs, which led her to start a tattoo apprenticeship.

Although art had always been a part of Meg's life, it was only when she discovered tattooing that she realized how art could become a career. She is now very happy to have a job that allows her to be creative every day and is grateful for the freedom she has with her work. Meg also feels indebted to her customers who have always been supportive and trusted her to create custom work in her own style. She explains, "I've always loved drawing, and tattooing allows me to do that on a daily basis and actually earn a living."

Asked whether tattoos are becoming more acceptable socially, Meg is of two minds. She comments, "I think things have changed drastically over the past ten years or so, even more so within the last five years that I've been a part of the industry. I think a lot of people would argue it's not a change for the good, but I think the changes have opened up the art of tattooing to a much wider audience, and something that was once considered quite taboo is now something that can appeal to anyone." As a fairly heavily tattooed woman, Meg finds that she still gets mixed reactions, but prefers to think most people just appreciate tattoos as an art form and means of personal expression.

Favorite designs, inspiration, and techniques

Meg's biggest inspiration for her tattoo designs is nature, including plants, insects, and birds. She also favors motifs such as horseshoes and crescent moons. Meg spends a lot of time researching florals and botanicals—in fact, she has endless reference books and images that she can work from. Meg likes to work on tattoos of all sizes, although she did more tiny tattoos when she first started out. Now, she prefers the variety of working at different scales—pointing out that one day she could be working on a full torso piece and the next on

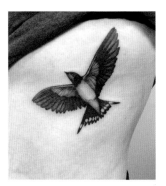

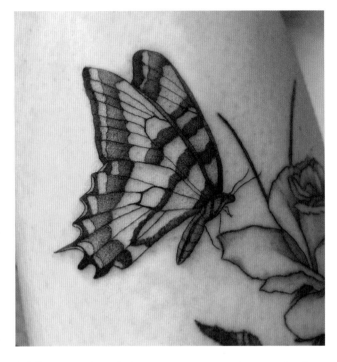

small matching tattoos. She stresses: "They are all just as important and meaningful, both to the client and to myself as an artist."

Meg admits that she is forever coming across artists who inspire her, although on first starting out she was constantly sent Rebecca Vincent's work as reference by customers and so feels that her work played a huge part in shaping her own career. Meg's and Rebecca's styles are quite different, but they both specialize in floral work. There are many other artists whose work Meg finds inspirational, but two of her favorites are Justin Olivier and Perry Smick.

Meg works in black and gray only and with delicate line work and shading. She prefers to work from realistic reference material, as she is aiming for a combination of illustrative and realistic floral work.

Advice on getting a tattoo

Meg believes that a tiny tattoo is a great starting point for those who are new to tattooing. It can feel less overwhelming, especially if it is a first tattoo—even just experiencing the tattooing process and environment can be daunting for many people. She emphasizes the importance of researching tattoo artists before committing so that people can feel confident they will be tattooed with something they're happy with. Meg points out that, although it's nice to have deep sentimental reasons for a tattoo, it's fine just to have one as a way of collecting art or for personal adornment.

> ## "TATTOOS ARE FOR EVERYONE. I DON'T SEE HOW THAT CAN BE A BAD THING."

ANATOMY

no. 573
Bones

no. 574
Foot skeleton

no. 575
Sign of the horns

no. 576
Knee joint

no. 577
Skull silhouette

no. 578
Skull and crossbones

no. 579
Love skull

no. 580
Skull with crown

no. 581
Simple skull

no. 582
Day of the Dead

no. 583
Punk skull

no. 584
Knee joint profile

no. 585
Rib cage

no. 586
Grinning skull

RATTLE MY BONES

Skeleton and particularly skull tattoos have been popular for decades. They can represent death or a significant life change and are traditionally considered the rebel's hallmark.

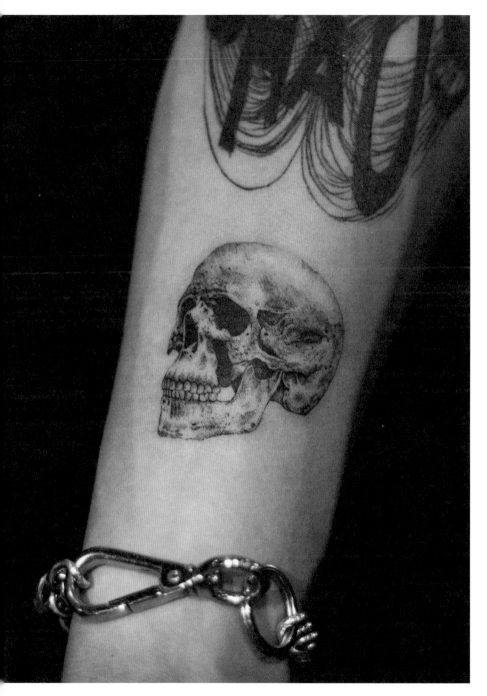

no. 587
Female reproductive
system

no. 588
Testes

no. 589
Brain

no. 590
Beating heart

no. 591
Lungs

no. 592
Intestines

no. 593
Hair follicle

no. 594
Eye

This is a fresh,
modern take on
the traditional
love heart.

no. 595
Stomach

no. 596
Kidneys

no. 597
Aerial brain

no. 598
Simple heart

POTENTIAL PAIRINGS

no. 691
Kiss of life

no. 701
Pills

no. 694
Medicine

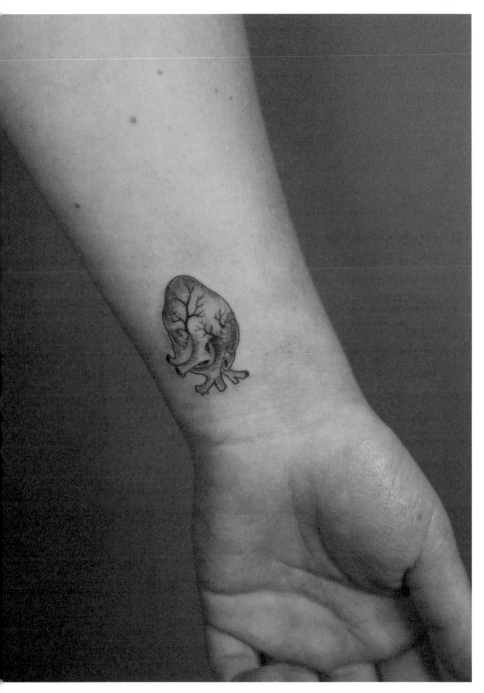

no. 599
Tooth and toothbrush

no. 600
Healthy tooth

no. 601
Tongue and lips

no. 602
Lips

no. 603
Tooth with cavity

no. 604
Tooth with brace

no. 605
Mustache

no. 606
Curly mustache

no. 607
Tooth silhouette

no. 608
3-D tooth

no. 609
Rotten tooth

no. 610
Chattering teeth

Pair this comb
with no. 605
or 606.

POTENTIAL PAIRINGS

no. 689
Pliers

no. 1004
Candy

no. 768
Comb silhouette

116

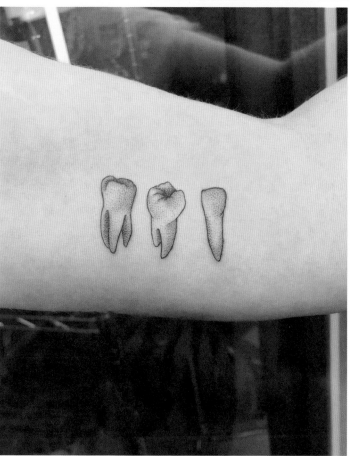

SCIENCE

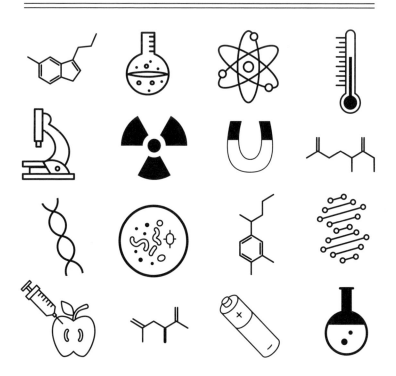

Science

no. 611
Adrenaline

no. 612
Noradrenaline

no. 613
Dopamine

no. 614
Glycine

Serotonin has become a popular tattoo to show support for mental health.

no. 615
Gamma-aminobutyric
acid (GABA)

no. 616
Glutamic acid

no. 617
Aspartic acid

no. 618
Serotonin

no. 619
Histamine

no. 620
N-Acetylaspartyl-
glutamic acid (NAAGA)

no. 621
Taurine

no. 622
Hydrogen, oxygen, and
nitrogen composition

POTENTIAL PAIRINGS

no. 625
Microscope

no. 631
DNA

no. 630
Test tube

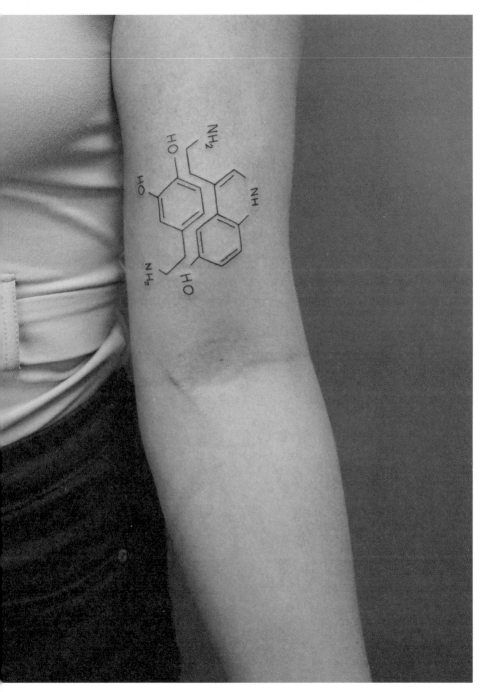

no. 623
Radiation

no. 624
Atom

no. 625
Microscope

no. 626
Thermometer

no. 627
Petri dish

no. 628
Modified apple

no. 629
Flask

Love science? Why not get a tiny test tube tattoo?

no. 630
Test tube

no. 631
DNA

no. 632
Double helix

no. 633
Magnet

no. 634
Battery

POTENTIAL PAIRINGS

no. 706
Apple for the teacher

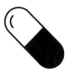

no. 700
Capsule

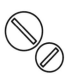

no. 701
Pills

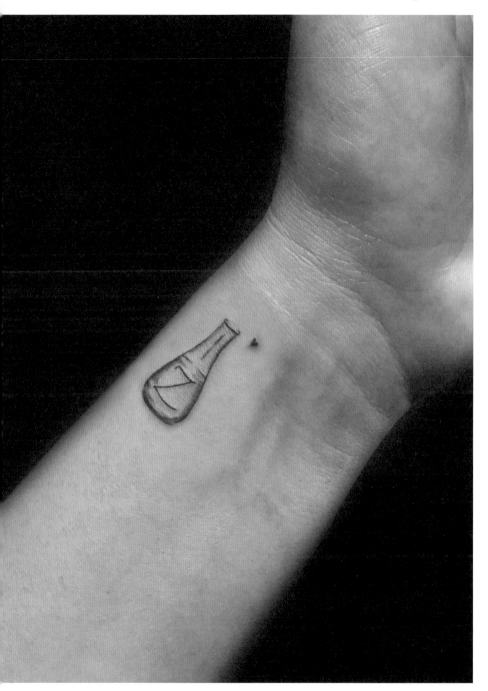

HANNAH PIXIE SNOWDON

Instagram @hannahpixiesnow
fromhannahpixiewithlove.com

Hannah Pixie Snowdon is a traveling tattoo artist who began tattooing at age 18. The first tattoo she did was on herself—"Some of my first ever tattoos were tiny love hearts, behind my ears. I still adore them." Although Hannah now has a full bodysuit, she feels a tiny tattoo is often appropriate because it can fulfill a need for a commemorative symbol in memory of a loved one. She has been tattooing for about ten years and enjoys the one-on-one connection. She explains, "To meet someone who is a practical stranger, to talk about everything and nothing, and then to wave them off with a permanent physical reminder of the time we have both spent together: it's the ultimate compliment for me and my art."

Hannah believes the best tattoo artists create from a pure place. She elaborates: "A tattoo, any interaction really, is an energy exchange. When

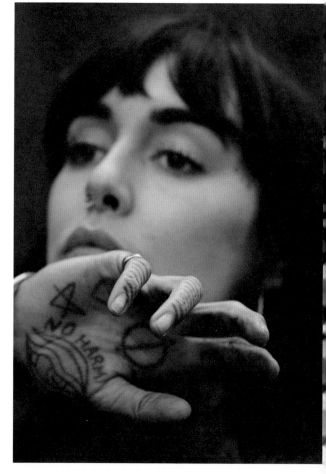

t's an unbalanced exchange, when you're doing it more for the money, the recognition, the praise, no matter how visually impressive it may be, the energy will be off." She recommends that people "find an artist on your own wavelength, one that helps you feel calm, collected, and someone who is empathetic in their nature."

Artistic inspiration and techniques

Most of Hannah's inspiration comes from nature. She elaborates: "Flowers are my favorite! More ornamental than realistic, though. Mushrooms, leaves, little animals, bigger animals—anything you'd find in the forest! I like to feel deeply connected to nature." Hannah prefers to use black and gray, and a few highlights for now, although she believes she will experiment with her style forever—"I'm keeping it simple for now . . . Big lines and fine dots always look great together; the contrast pops."

Working mostly freehand, Hannah draws natural forms directly on the skin. This allows her to create something straight from the heart."

Although she concedes modern technology is incredible and that many tattoo artists now use iPads, she deliberately chose not to use tech, so she could work in a simpler and more natural way. Explaining her working process, she comments, "I never have a plan when I meet my customer, really. All I need is an area and an idea of budget (so I don't get carried away), plus an idea of what my client is into visually. Next comes the magic!"

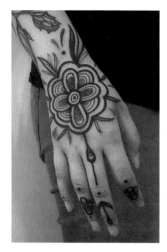

"I BELIEVE THERE IS SOMETHING SHAMANISTIC IN THE EXCHANGE OF ENERGY WHEN YOU'RE MARKING SOMEONE FOR LIFE."

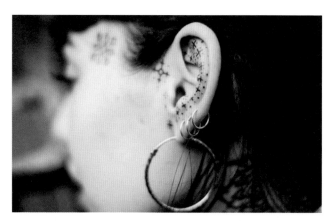

TOOLS OF THE TRADE

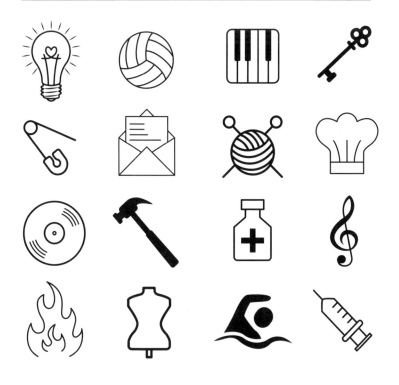

no. 635
Soccer ball

no. 636
Football helmet

no. 637
Baseball mitt

no. 638
Baseball bat and ball

no. 639
Tennis

no. 640
Tennis ball

no. 641
Basketball hoop

no. 642
Volleyball

no. 643
Kettlebell

A tiny dumbbell would work on a bulging bicep.

no. 644
Dumbbell

no. 645
Ice skate

no. 646
Football

SPORTING PRIDE

Whether you work in a particular sport or enjoy it on the weekend, communicate your pride and passion to the world by getting inked.

no. 647
Pool

no. 648
Eight ball

no. 649
Archery

no. 650
Running

no. 651
Swimming

no. 652
Golf

no. 653
Golf ball

no. 654
Bowling

no. 655
Shuttlecock

no. 656
Rollerblade

no. 657
Table tennis

no. 658
Boxing glove

no. 659
Stopwatch

no. 660
Trophy

no. 661
Medal

no. 662
Whistle

no. 663
Key

no. 664
Good luck key

no. 665
Love key

no. 666
Key of the door

no. 667
Locket

no. 668
Key silhouette

no. 669
Eco bulb

no. 670
Bulb with filament

no. 671
Spiral bulb

no. 672
Swirly bulb

no. 673
Prong bulb

no. 674
Simple bulb

no. 675
Light bulb moment

no. 676
Shining bulb

HOUSEHOLD OBJECTS

Household objects can make for unusual tattoos. Light bulbs are symbols of brightness and vision; choose an energy-efficient design for a fresh spin on the light bulb moment.

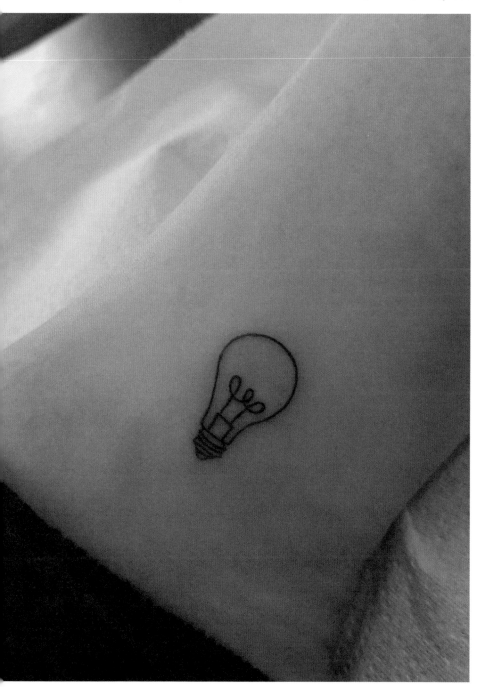

Tools of the trade

If you are a builder, why not get a mini toolbox tattoo?

no. 677
Saw blade

no. 678
Screw

no. 679
Toolbox

no. 680
G-clamp

no. 681
Trowel

no. 682
Saw

no. 683
Socket wrench

no. 684
Roller

no. 685
Adjustable wrench

no. 686
Screwdriver

no. 687
Hammer

CONSTRUCTION TOOLS

If you work in the construction industry, you could get one or more relevant tiny tattoos to demonstrate your commitment to your clients.

no. 688
Wrench

no. 689
Pliers

no. 690
Anvil

no. 691
Kiss of life

no. 692
Stethoscope

Show your
love for
healing
people with
a tiny first aid
kit tattoo.

no. 693
First aid kit

no. 694
Medicine

no. 695
Cross silhouette

no. 696
Wheelchair

no. 697
Water droplet

no. 698
Clipboard

no. 699
Syringe

no. 700
Capsule

no. 701
Pills

no. 702
Awareness ribbon

POTENTIAL PAIRINGS

no. 598
Simple heart

no. 644
Dumbbell

no. 579
Love skull

Tools of the trade

If you enjoy keeping a diary, honor it with this tattoo.

no. 703
Simple book

no. 704
Secret diary

no. 705
Open book

no. 706
Apple for the teacher

no. 707
Books

no. 708
Fountain pen

no. 709
Ballpoint pen

no. 710
Pencil

no. 711
Doodle

no. 712
Letter

no. 713
Love letter

WRITTEN IN INK

You may be a professional writer, a budding novelist, or just love to write for your own enjoyment. Show your passion for the written word by getting one of these cute tattoos.

no. 714
Quill

no. 715
Ink pot

no. 716
Quill and ink

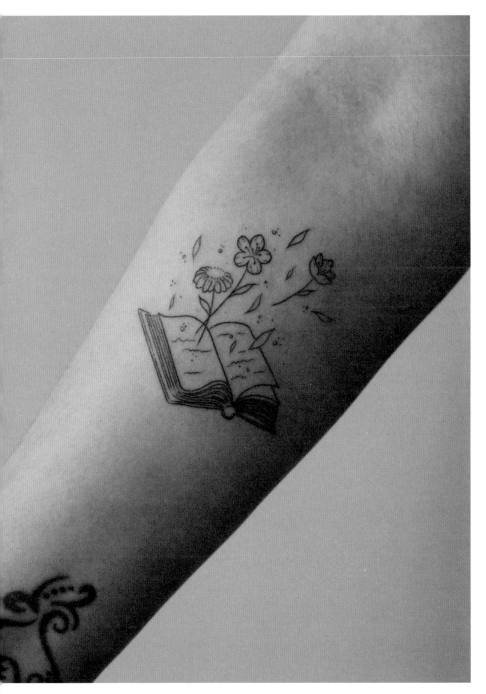

Tools of the trade

no. 717
Coat hanger

no. 718
Dress form

no. 719
Scissors

no. 720
Zipper

no. 721
Pincushion

no. 722
Thimble

no. 723
Buttons

no. 724
Tape measure

no. 725
Crochet hook

no. 726
Knitting needles

no. 727
Cone of yarn

CRAFTY TOOLS

If you enjoy
knitting,
sewing, or
crocheting,
why not
display
your love of
crafting by
getting one
of these fun
designs.

no. 728
Spool of thread

no. 729
Needle and thread

no. 730
Safety pin

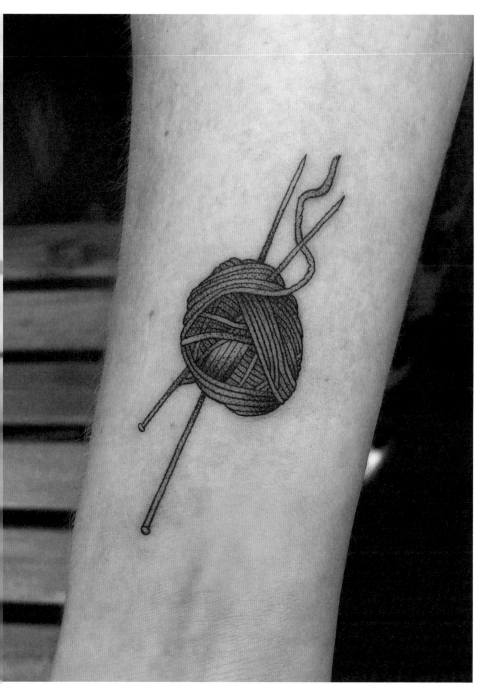

Tools of the trade

no. 731
Saxophone

no. 732
Microphone

no. 733
DJ

no. 734
Volume

no. 735
Record player

no. 736
Retro microphone

Mark your musical achievements by getting a tiny tattoo.

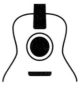

no. 737
Cassette

no. 738
Record

no. 739
Electric guitar

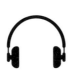

no. 740
Headphones

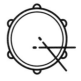

no. 741
Acoustic guitar

MAKING MUSIC

You may have passed a significant music exam recently or may have made a career out of music. Either way, select your favorite symbol from these designs and get inked.

no. 742
Keyboard

no. 743
Metronome

no. 744
Drum

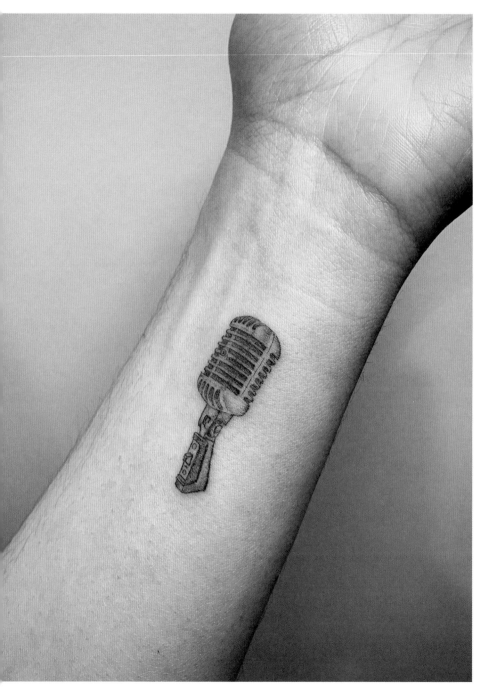

no. 745
Flat

no. 746
Quarter note

no. 747
Eighth notes

no. 748
Sharp

no. 749
Repeat

no. 750
Treble clef

no. 751
Quarter note

no. 752
Eighth-note rest

Use these designs to
create a tattoo of your
favorite piece of music.

no. 753
Bass clef

no. 754
Whole note

no. 755
Quarter rest

no. 756
Half note

POTENTIAL PAIRINGS

no. 743
Metronome

no. 742
Keyboard

no. 740
Headphones

Tools of the trade

no. 757
Shears

no. 758
Graphic scissors

no. 759
Straight razor

no. 760
Shaver

no. 761
Mirror

no. 762
Hair clippers

Mark your career in the hair industry by getting a tiny comb.

no. 763
Comb

no. 764
Fragrance

no. 765
Bobby pin

no. 766
Hair dryer

no. 767
Shaving brush

no. 768
Comb silhouette

POTENTIAL PAIRINGS

no. 606
Curly mustache

no. 703
Simple book

no. 456
Beer

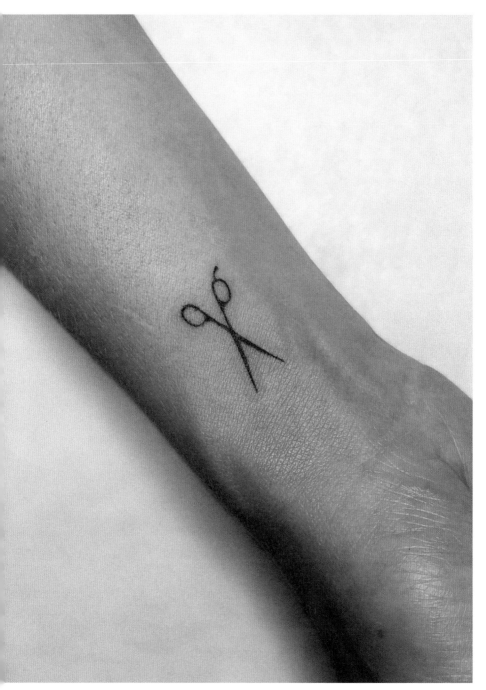

Tools of the trade

If you work in a professional kitchen, get a tiny knife tattoo.

no. 769
Balloon whisk

no. 770
Knife

no. 771
Knife silhouette

no. 772
Cleaver

no. 773
Fire

no. 774
Spatula and rolling pin

no. 775
Weighing scale

no. 776
Corkscrew

no. 777
Colander

no. 778
Chef's hat

no. 779
Bubbling pot

no. 780
Salt and pepper

no. 781
Oven mitt

no. 782
Spatula

CHEF'S TOOLS

If you have a passion for cooking or simply watching the TV shows, why not get a whisk or a chef's hat? An arrangement of tiny kitchen utensils makes for an interesting tattoo.

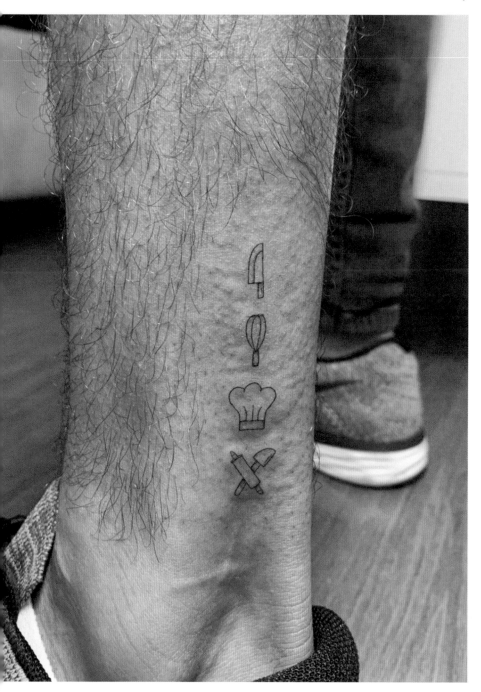

GEORGINA HAWKES

Topboy Tattoo, Hove
Instagram @geehawkestattoo

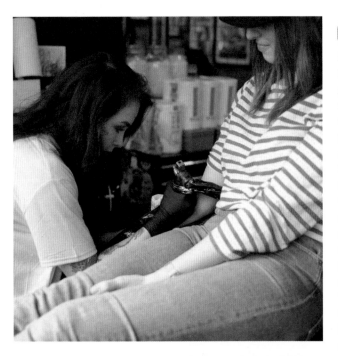

Georgina Hawkes is fortunate to have a dad wh is also a tattoo artist and took her on as an apprentice—"I'm grateful to my dad for teaching me a skill that allows me to use my creative side daily." The first tattoo Georgina ever did—three little cherry blossoms—was on one of her dad's friends. As she explains, "I've only ever tattooed myself once and that was a tiny heart on my ankle." Georgina loves tattooing because it allows her to be creative and to meet new people. She points out, "I'm always overwhelmed and so, so grateful for the level of trust people give me with their designs and their bodies." She also finds tattooin therapeutic, immersing hersel in the process and feeling mor relaxed as a result.

Georgina began doing tiny tattoos because they appeal to a wider audience, especially people who may not have considered a tattoo before. She thinks most people opt for a

tiny tattoo as it enables them to express their creativity in a subtle way. Most of her clients stick to areas such as the ankles, wrists, and ribs, but she comments that "if you want to get a tiny tattoo in the middle of your forearm and it'll make you happy, absolutely go for it!"

Favorite tattoo designs

Georgina is influenced by nature, especially floral designs—in fact, she loves tattooing all kinds of plants. As she explains, "When it comes to smaller pieces, I'm drawn to scaled-down florals and flowing handwriting—they always look so delicate and beautiful on the skin." She finds botanical motifs work especially well as tiny tattoos because they can be detailed or simple, as necessary. She comments: "I am a huge fan of Art Nouveau artwork and also Victorian floral/botanical sketches and etchings." Georgina also enjoys creating little landscape scenes in dotted circles with stars and stylized skylines. Georgina favors fine line work and dot work because this best suits her skills and appeals to her client base. She elaborates, 'I tattoo a huge percentage

of women who want quite delicate/dainty tattoos." In terms of artistic influences, she is drawn to artists, both past and present, whose work shows true passion, even if the work is different from her own.

"I LOVE HOW HAPPY A TATTOO CAN MAKE A CLIENT AND IN A LOT OF SITUATIONS MAKE THEM MORE CONFIDENT WITH THEIR BODY TOO."

SYMBOLS

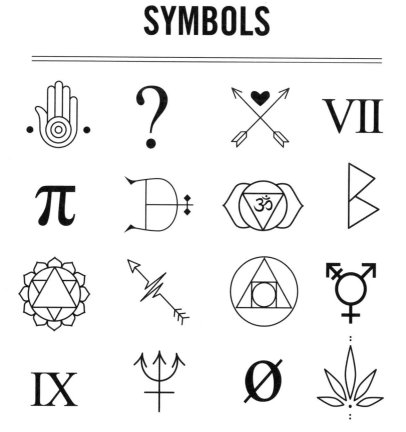

A semicolon tattoo is a symbol to raise awareness of mental health issues.

no. 783
Colon

no. 784
Semicolon

no. 785
Apostrophe

no. 786
Ellipsis

no. 787
Esh symbol

no. 788
Asterisk

no. 789
Dash

no. 790
Parentheses

no. 791
Slash

no. 792
Exclamation point

no. 793
Question mark

no. 794
Single quotes

no. 795
Ampersand

no. 796
Guillemets

SYMBOLS OF LIFE

Punctuation marks organize and bring meaning to the written word. They may symbolize separation, emphasis, or a pause for thought, so choose the design that works for you.

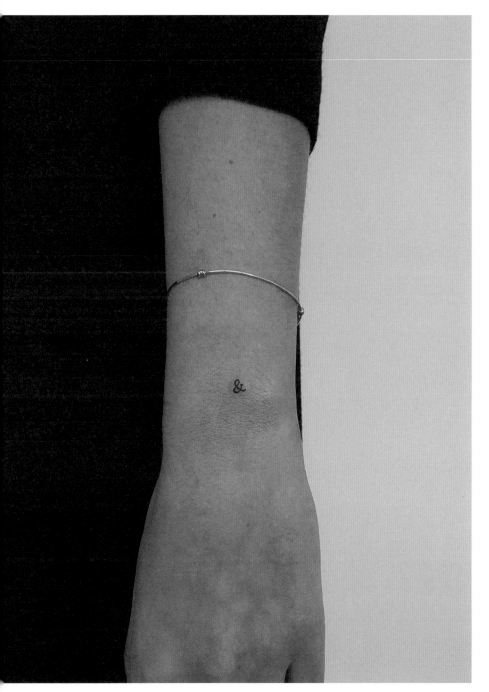

I

no. 797
One

II

no. 798
Two

III

no. 799
Three

IV

no. 800
Four

V

no. 801
Five

VI

no. 802
Six

VII

no. 803
Seven

VIII

no. 804
Eight

IX

no. 805
Nine

X

no. 806
Ten

L

no. 807
50

C

no. 808
100

D

no. 809
500

M

no. 810
1,000

ROMAN NUMERALS

Tattoos of Roman numerals often represent a significant date or year in a person's life. The numerals could be illustrated with other relevant tiny tattoos.

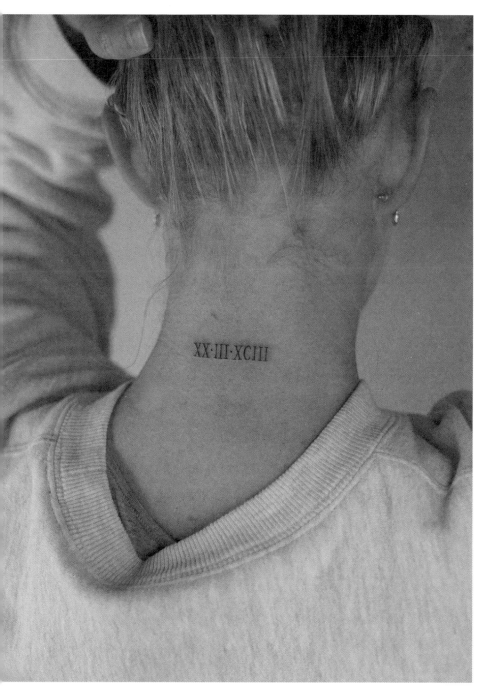

Crossed arrows can represent friendship.

no. 811
Bobble shaft arrow

no. 812
Crossed heart arrows

no. 813
Pulsing arrow

no. 814
Triangle head arrow

no. 815
Feather flight arrow

no. 816
Arrow silhouette

no. 817
Monochrome arrow

no. 818
Dotted shaft arrow

no. 819
Heart flight arrow

no. 820
Downy flight arrow

no. 821
Curl flight arrow

no. 822
Striped head arrow

POINTING THE WAY

Arrows often symbolize direction and can look striking tattooed in any style. It is advisable to choose a larger arrow size to prevent blur, since the flights can be detailed.

no. 823
Contrast arrow

no. 824
Wing flight arrow

no. 825
Heart shaft arrow

no. 826
Cross shaft arrow

no. 827
Cone head arrow

no. 828
Delicate arrow

no. 829
Leafy flight arrow

no. 830
Mini flight arrow

no. 831
Triangle flight arrow

no. 832
Twirly arrow

no. 833
Curly arrow

no. 834
Heart head arrow

no. 835
Dotted flight arrow

no. 836
Fiery flight arrow

no. 837
Speckled flight arrow

no. 838
Bunch of arrows

no. 839
Female

no. 840
Male

no. 841
Bigender

no. 842
Androgyne

no. 843
Transgender

no. 844
Neutrois

no. 845
Agender

no. 846
Polygender

no. 847
Genderqueer

no. 848
Aliagender

no. 849
Genderfluid

no. 850
Epicene

POTENTIAL PAIRINGS

no. 969
Heart

no. 784
Semicolon

no. 812
Crossed heart arrows

no. 851
Hamsa

no. 852
Om

no. 853
Tree of life

no. 854
Looping mandala

no. 855
Lotus with prayer

no. 856
Lotus position

no. 857
Relaxation

no. 858
Chakras

no. 859
Flower mandala

no. 860
Patterned mandala

no. 861
Teardrop mandala

no. 862
Graphic lotus

A HIGHER PLANE

For those who practice yoga, a tattoo can be a special
way of honoring the way of life. Yoga symbols
represent courage (hamsa), purity (lotus flower),
unity (mandala), and spiritual enlightenment (om).

Mandalas are used as an aid
for meditation.

no. 863
Overlapping lotus

no. 864
Symmetrical lotus

no. 865
Dahlia mandala

no. 866
Graphic om

no. 867
Sunflower mandala

no. 868
Star mandala

no. 869
Triangle mandala

no. 870
Moon mandala

no. 871
Ganesha

no. 872
Lotus silhouette

no. 873
Lotus with candle

no. 874
Spotted lotus

no. 875
Simple lotus

no. 876
Yogic enlightenment

no. 877
Meditation

no. 878
Namaste

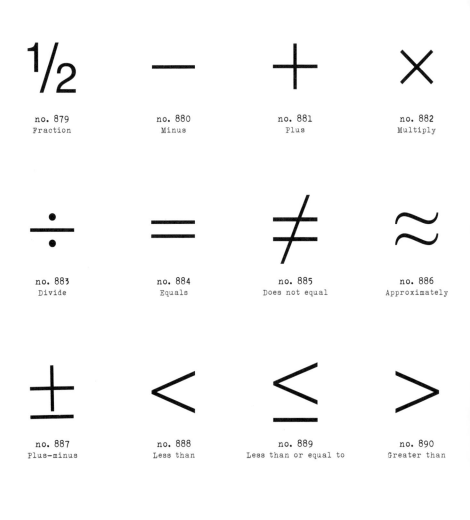

no. 879
Fraction

no. 880
Minus

no. 881
Plus

no. 882
Multiply

no. 883
Divide

no. 884
Equals

no. 885
Does not equal

no. 886
Approximately

no. 887
Plus-minus

no. 888
Less than

no. 889
Less than or equal to

no. 890
Greater than

MATH SYMBOLS

Without these symbols, mathematical calculations as
we know them would be impossible. They illustrate the
myriad ways in which numbers can relate to one another
and are fundamental to our understanding of the world.

The infinity sign represents never-ending possibilities.

no. 891
Greater than or equal to

no. 892
Infinity

no. 893
Empty set

no. 894
Percent

no. 895
Square root

no. 896
Therefore

no. 897
Because

no. 898
Decimal point

$|x|$

no. 899
Absolute value

~

no. 900
Similarity

||

no. 901
Exact

no. 902
Congruence

π

no. 903
Pi

α

no. 904
Proportional

no. 905
Beta function

Σ

no. 906
Sum

no. 907
Fire

no. 908
Air

no. 909
Water

no. 910
Earth

no. 911
The elements

no. 912
Silver (Moon)

no. 913
Mercury

no. 914
Copper (Venus)

no. 915
Gold (Sun)

no. 916
Mars

no. 917
Tin (Jupiter)

ELIXIR OF LIFE

Alchemy was the ancient philosophy and practice of seeking to transform base metals into gold. Alchemical symbols have individual meanings, but broadly represent change and enlightenment.

no. 918
Lead (Saturn)

no. 919
Uranus

no. 920
Neptune

no. 921
Earth

no. 922
Pluto

no. 923
Sulfur

no. 924
Philosopher's stone

no. 925
Magnesium

no. 926
Zinc

no. 927
Potassium

no. 928
Bismuth

no. 929
Lithium

no. 930
Salt

no. 931
Iron

no. 932
Arsenic

no. 933
Platinum

no. 934
Phosphorus

Symbols

no. 935
Mannaz (man)

no. 936
Gebo (gift)

no. 937
Ansuz (A god)

no. 938
Othila (homeland)

no. 939
Uruz (wild bull)

no. 940
Perthro (unknown)

no. 941
Nauthiz (need)

no. 942
Inguz (seed)

no. 943
Eihwaz (yew)

no. 944
Algiz (elk)

Fehu symbolizes wealth and mobile property.

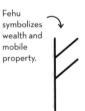

no. 945
Fehu (cattle)

MEANING BEHIND THE MAGIC

The meanings of the runes (symbols with mysterious or magic significance) are connected with fertility, weather, sunlight, darkness, and the cycle of the seasons.

no. 946
Wunjo (joy)

no. 947
Jera (year)

no. 948
Kenaz (torch)

READING THE RUNES

Symbols are popular tattoos; however, it is important to become familiar with their meanings before considering getting them inked on your body.

no. 949
Tiwaz (the god Tyr)

no. 950
Berkano (birch goddess)

no. 951
Ehwaz (horse)

no. 952
Laguz (water)

no. 953
Hagalaz (hail)

no. 954
Raido (ride)

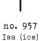

no. 955
Thurisaz (giants)

no. 956
Dagaz (day)

no. 957
Isa (ice)

no. 958
Sowilo (sun)

165

ESZTER DAVID

Parliament Tattoo, London
Instagram @eszterdavidtattoo

Eszter David is a tattoo artist at Parliament Tattoo in London. She fell in love with tattooing at age 14 when her mum got a big tattoo. The first tattoo Eszter did was a freehand tribal design for her friend to cover up an older piece. Eszter jokes: "We are still friends! Making the first tattoo makes you smile for days!" Personally, she now has a few smaller tattoos, including a triangle, some dots, letters, and a love heart.

Eszter believes there is now less stigma surrounding tattoos, although facial and hand tattoos can still be a problem. For this reason, she feels the best place for a tiny tattoo is on the arms, legs, sternum, or back, or perhaps behind the ear. That said, she advises people considering a tattoo against getting them on the face or hand. Eszter also suggests that people do their research thoroughly to find a tattoo artist with a style they like. She feels that trust

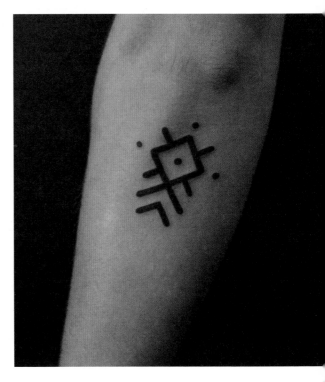

"IF A TATTOO IS SMALL, IT'S BEST TO KEEP IT SIMPLE—I LIKE SMALL GEOMETRIC DESIGNS OR SYMBOLS, TINY ORNAMENTAL PIECES."

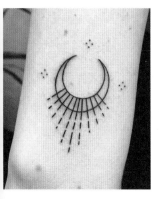

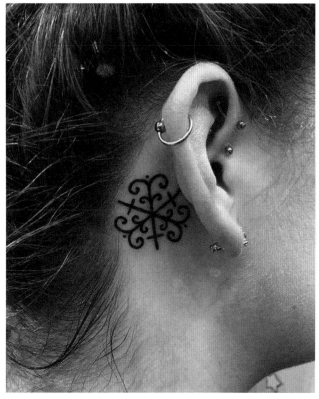

between the artist and the client is essential too. As Eszter points out: "Good tattoos aren't cheap; cheap tattoos aren't good."

Artistic influences, designs, and techniques

In terms of artistic influences, Eszter is inspired by nearly everything. She has a collection of books at home that she turns to when stuck for ideas. She finds her coworkers are also a huge influence on her work.

Eszter particularly enjoys tattooing ornamental features, Egyptian designs, statues, and anything involving fine lines, from flowers to geometric shapes. For ornamental pieces, Eszter usually only needs to know which part of the body she is going to tattoo before she starts drawing to ensure

the design will fit the area. She then simply uses the best technique for the design. Eszter comments, "These designs I just draw from my head, as I've been tattooing them for years now." However, she generally makes a quick sketch first, which usually takes only a few minutes, before finalizing the design the next day or the following week.

Eszter really enjoys everything about tattooing, including the drawing process, peeling off the stencil, the sound of the machines, and the smell of disinfectant. As Eszter explains, "I love seeing a happy client with a healed tattoo!"

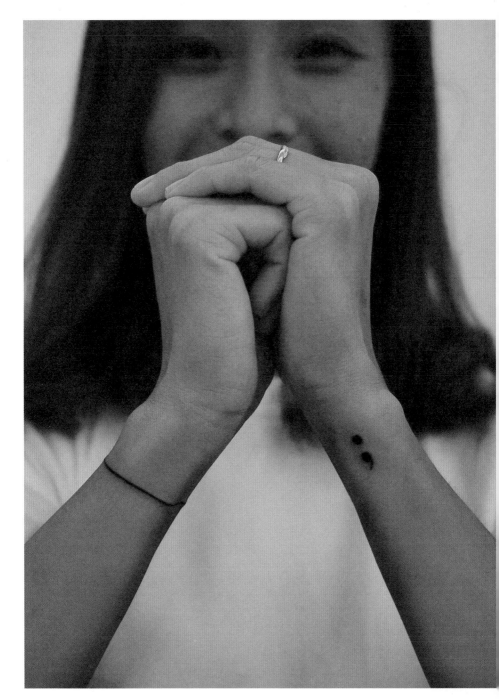

10

PATTERNS AND SHAPES

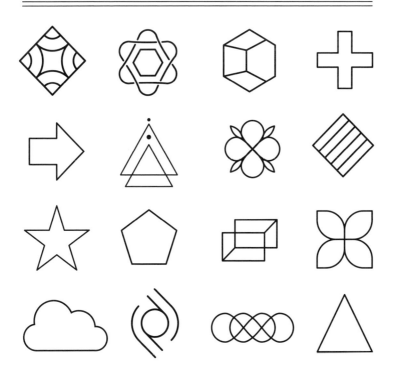

Patterns and shapes

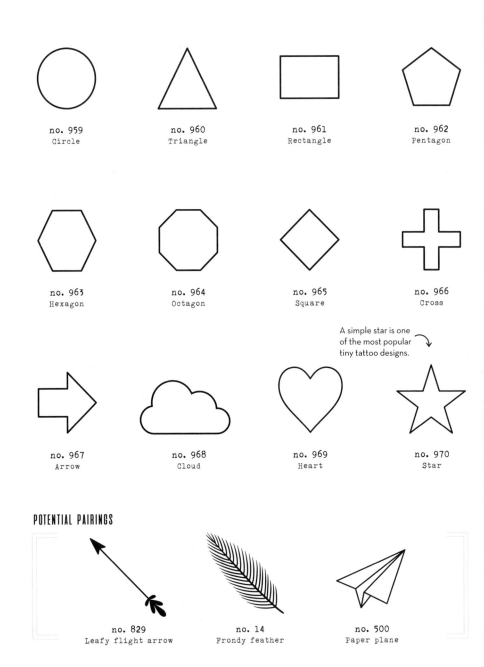

no. 959
Circle

no. 960
Triangle

no. 961
Rectangle

no. 962
Pentagon

no. 963
Hexagon

no. 964
Octagon

no. 965
Square

no. 966
Cross

A simple star is one of the most popular tiny tattoo designs.

no. 967
Arrow

no. 968
Cloud

no. 969
Heart

no. 970
Star

POTENTIAL PAIRINGS

no. 829
Leafy flight arrow

no. 14
Frondy feather

no. 500
Paper plane

no. 971
Overlapping triangles

no. 972
Overlapping squares

no. 973
Striped circle

no. 974
Triangle with dots

no. 975
Square flower

no. 976
Circle and semicircles

no. 977
Three squares

no. 978
Teardrop flower

no. 979
Rectangle with pattern

no. 980
Loopy line

no. 981
Teardrops and squares

no. 982
Intersected rectangle

GEOMETRIC SHAPES

Simple geometric shapes work beautifully as tiny tattoos. You could create a stunning bespoke group design from the individual elements shown here.

no. 983
Connected rectangles

no. 984
Geometric shape

no. 985
Striped jewel

no. 986
Slanted geometric
shape

no. 987
Hexagon with stripe

no. 988
Striped square

no. 989
Pinwheel

no. 990
Swirly square

no. 991
Flower in square

no. 992
Triangles and hexagon

no. 993
Looped infinity

no. 994
Triangle and circle

no. 995
Curly circle

no. 996
3-D hexagon

no. 997
Jewel

no. 998
Intersecting triangles

SPIRIT WORLD

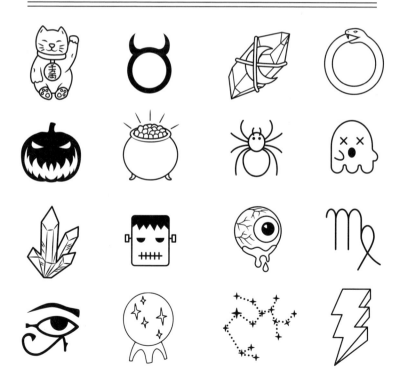

no. 999
Creepy pumpkin

no. 1000
Pumpkin silhouette

no. 1001
Flying bat

no. 1002
Roosting bat

no. 1003
Grim reaper

no. 1004
Candy

no. 1005
Clown

no. 1006
Witch's boot

If a black cat crosses
your path, why not get
one tattooed?

no. 1007
All-seeing eye

no. 1008
Black cat

no. 1009
Gravestone

no. 1010
Voodoo gingerbread man

SPOOKY TATTOOS

If you love Halloween, there are many
possibilities for tiny tattoos; the pumpkin
is perhaps the most popular. Design your
own scary face for a unique twist.

no. 1011
Frog

no. 1012
Ouroboros

no. 1013
Grim reaper silhouette

no. 1014
Halloween date

no. 1015
Crown

no. 1016
Ghost

no. 1017
Friendly ghost

no. 1018
Spooked!

no. 1019
Lightning bolt

no. 1020
Lightning silhouette

no. 1021
Spider

no. 1022
Rat silhouette

no. 1023
Vampire fangs

no. 1024
Vampire

no. 1025
Frankenstein's monster

no. 1026
Sands of time

Spirit world

no. 1027
Spiderweb

no. 1028
Skull with candle

no. 1029
Magic wand

no. 1030
Devil horns

no. 1031
Wings

no. 1032
Winged heart

no. 1033
Crystal ball

no. 1034
Bloody cleaver

no. 1035
Castle silhouette

no. 1036
Worms

no. 1037
Grim reaper's scythe

no. 1038
Candle

GHOULISH DESIGNS

There are many other supernatural and magic-themed Halloween emblems shown here; you could create your own ghoulish tiny tattoo collage.

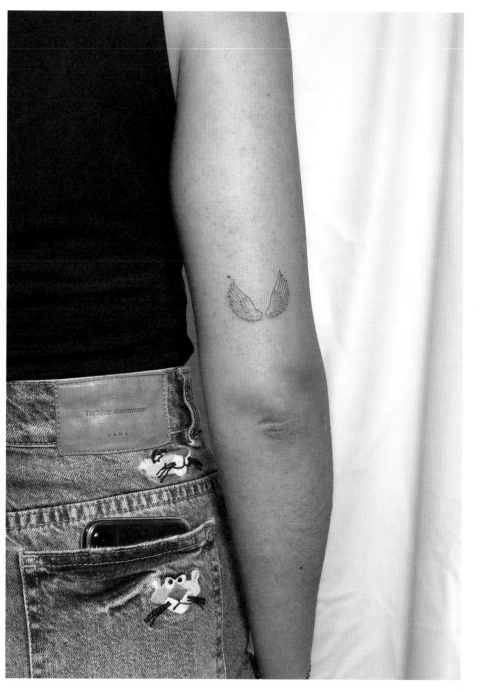

no. 1039
Vampire slayer

no. 1040
Severed finger

no. 1041
Witch's hat

no. 1042
Book of spells

no. 1043
Cauldron

no. 1044
Potion

no. 1045
Eye with tendrils

no. 1046
Simple eye

Share your eyeball
tattoo with the world
every Halloween!

no. 1047
Gooey eyeball

no. 1048
Bloody eye

no. 1049
Lightning tree

no. 1050
Coffin

no. 1051
Bloody dagger

no. 1052
Fiery skull

no. 1053
Severed hand

no. 1054
Undead

no. 1055
Maneki neko
(fortune cat)

no. 1056
Cornucopia

no. 1057
Pot of gold

no. 1058
Scarab beetle

The scarab beetle
was a popular design
for good luck charms
in ancient Egypt.

no. 1059
Genie's lamp

no. 1060
Dice

no. 1061
Horseshoe

no. 1062
Number seven

no. 1063
Wishbone

no. 1064
Eye of Horus

no. 1065
Money bag

no. 1066
Fingers crossed

POTENTIAL PAIRINGS

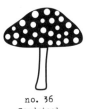

no. 36
Toadstool

no. 337
Genie

no. 1007
All-seeing eye

no. 1067
Geometric crystal

no. 1068
Crystal rods

no. 1069
Hexagonal crystal

no. 1070
Natural crystal

no. 1071
Triple crystal

no. 1072
Faceted crystal

no. 1073
Crystal group

no. 1074
Natural amethyst

no. 1075
Sparkling gem

no. 1076
Aerial gem

no. 1077
Gem silhouette

no. 1078
Pear cut

CRYSTALS AND GEMS

Whether you practice crystal healing or are
a lover of gemstones, you are sure to find an
inspirational tiny tattoo design on these pages.

no. 1079
Heart cut

no. 1080
Round cut

no. 1081
Crystal cuts

no. 1082
Ring silhouette

Show your passion for crystal healing with this tattoo.

no. 1083
Healing crystal

no. 1084
Random crystal

no. 1085
Nature energy crystal

no. 1086
Moon energy crystal

no. 1087
Prism crystal

no. 1088
Crystal points

no. 1089
Uniform crystal

no. 1090
Floating crystal

no. 1091
Jewel and the crown

no. 1092
Jewel with wings

no. 1093
Crystal necklace

no. 1094
Jewel silhouette

no. 1095
Aries

no. 1096
Aries constellation

no. 1097
Taurus

no. 1098
Taurus constellation

no. 1099
Gemini

no. 1100
Gemini constellation

no. 1101
Cancer

no. 1102
Cancer constellation

no. 1103
Leo

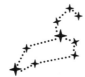

no. 1104
Leo constellation

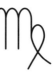

no. 1105
Virgo

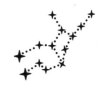

no. 1106
Virgo constellation

SIGNS OF THE ZODIAC

The human race has always been
fascinated by stars, so it is no wonder
that zodiac tattoos are so popular.

no. 1107
Libra

no. 1108
Libra constellation

no. 1109
Scorpio

no. 1110
Scorpio constellation

no. 1111
Sagittarius

no. 1112
Sagittarius constellation

no. 1113
Capricorn

no. 1114
Capricorn constellation

no. 1115
Aquarius

no. 1116
Aquarius constellation

no. 1117
Pisces

no. 1118
Pisces constellation

Index

Index

Credits

The publisher would like to thank the following sources for their kind permission to reproduce the photographs in this book:

@jingstattoo: pages 1, 93; @inkbyfrank: pages 3, 49, 51, 53, 55, 57, 59, 61, 69, 115, 121, 153; @dindottattoo: pages 7 (cr), 25, 28, 29, 65, 67, 79, 95, 103; @ellabelltattoo: pages 7 (br), 88, 89; @rebecca_vincent_tattoo: pages 9, 11, 12; Abraham D. Tayeh/D'Tayeh Tattoo, Bogotá Colombia: pages 35, 45, 68, 85, 139, 145; Zaya: pages 37, 73; @armelle_stb_tattoo: pages 40, 41; @yamoztattoo: page 63; Alex Denver: pages 75, 169; Loxluna.tattooing from NRDYMTCH Ink: page 77; Handpoked by Kelly Needles: pages 83, 157; Can Levi: page 87; @paradisehellbow: page 98; Pedro Miranda/dr.pressence: page 105; @meglangdaletattoo: pages 108, 109; Young/@youngtatsyou: page 113; @marthasmithtattoo: pages 117, 137; @an.i.tattoo: page 123; @hannahpixiesnow: pages 124, 125; @lucyellenart: page 131; Arte&Amor Tattoo by João Gonçalves: page 141; Handpoked by Dots by Kim: page 143; @geehawkestattoo: pages 135, 146, 147; Chara Kyriakidou/chara_tattooer: page 151; @eszterdavidtattoo: pages 166, 167; @jimmyyuen: page 168; Kathryn: page 173; @tattoobychang: page 181.